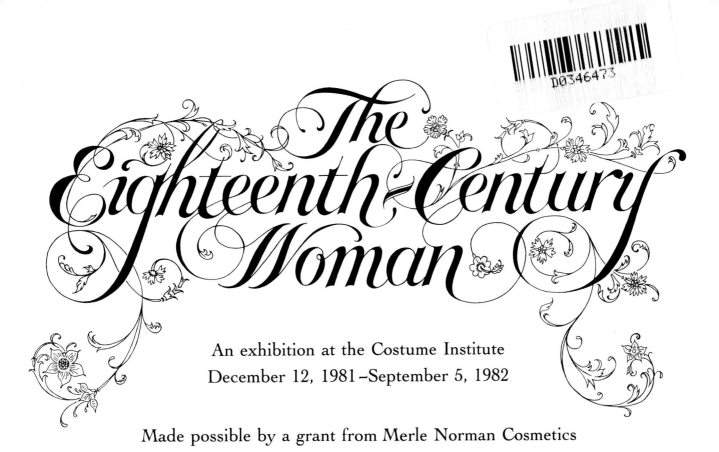

The Eighteenth-Century Woman

An exhibition at the Costume Institute
December 12, 1981–September 5, 1982

Made possible by a grant from Merle Norman Cosmetics

Text by Paul M. Ettesvold
Assistant Curator, The Costume Institute

THE METROPOLITAN MUSEUM OF ART, NEW YORK

Published by The Metropolitan Museum of Art, New York
Bradford D. Kelleher, Publisher
John P. O'Neill, Editor in Chief
Polly Cone, Emily Garlin, Editors
Roberta Savage, Designer
Carole Lowenstein, Calligrapher

Typeset by Westchester Book Composition
Printed by Colorcraft Lithographers, Inc.
Color photography by Lynton Gardiner,
 Photograph Studio, The Metropolitan Museum of Art

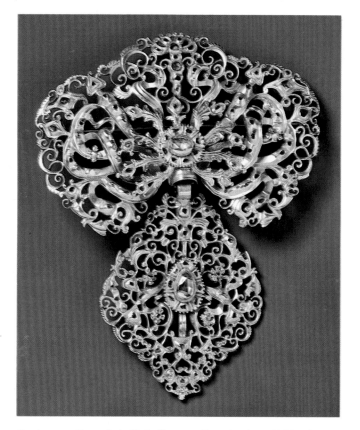

Many people have helped gather the art objects together for this exhibition, both from European and American museums and from private collections. A special debt of gratitude is owed Ingrid Bergman, the Nordiska Museum; Mogens Bencard, the Rosenborg Palace; Madeleine Delpierre, Musée de la Mode et du Costume; Yvonne Deslandres, Union Française des Arts du Costume; Nadine Gasc, Musée des Arts Décoratifs; Bianca du Mortier, the Rijksmuseum; Richard Robson, Castle Howard; Ann Coleman, The Brooklyn Museum; Adolph Cavallo, the Philadelphia Museum of Art; Claudia Kidwell, the National Museum of American History.

Metropolitan Museum colleagues have been extremely generous with their time and knowledge, particularly Clare Le Corbeiller, Alice Zrebiec, Jean Mailey, James Draper, James Parker, Helmut Nickel, Katharine Baetjer, David Kiehl, Carol Cardon, Mark Cooper, and Lynton Gardiner. I am personally very grateful to Lindsay Soutter, my research assistant, who was untiring in her efforts to complete the catalogue entries. Above all, I thank Stella Blum, curator of the Costume Institute, for her constant support and encouragement of this project.

P.M.E.

On the cover: Brocaded silk ball gown. French, about 1770. The Metropolitan Museum of Art. Purchase, Irene Lewisohn Bequest, 1961. CI. 61.13.1ab

Back cover: Chiné-patterned silk taffeta. Detail of an afternoon dress. French, about 1770. The Metropolitan Museum of Art. Purchase, Irene Lewisohn Bequest, 1960. CI 60.40.2ab

Above: Brooch pendant of diamonds set in gold. Portuguese, early 18th century. The Metropolitan Museum of Art. Gift of Marguerite McBey, 1980. 1980.343.9

Right: Satin-striped silk faille evening gown spot brocaded with flowers and leaves. English, 1770. The Metropolitan Museum of Art. Purchase, Irene Lewisohn Bequest, 1962. CI 62.29.1ab

Contents

Foreword

Foreword

The eighteenth century before the outbreak of the French Revolution was a time marked by extravagance and splendor in the lives of the elite. It was also an era of great change — a time during which science and economic theory flourished along with the currents of radical thought that were to bring down the monarchy. It is a paradox that the century was profoundly feminine in its character. Women were involved in all aspects of the arts, politics, and intellectual life. For women of the upper class, fashion was a matter of primary concern, and it is, therefore, through fashion that one learns so much about daily life during the *ancien régime*.

The Metropolitan Museum has been collecting French costumes and accessories since the turn of the century and has one of the most comprehensive collections in the world. It is, then, no surprise that the current exhibition, *The Eighteenth-Century Woman*, is a remarkable selection of riches culled from the Costume Institute's vast holdings and augmented with paintings, sculpture, other costumes, and decorative arts from other departments and collections. In view of Diana Vreeland's long career in fashion, it is most appropriate that she should select eighteenth-century costume as the theme of her tenth consecutive exhibition at the Museum. The eighteenth century was, of course, the era during which women surpassed men in the richness of their dress. Mrs. Vreeland, as special consultant to the Costume Institute, has brought her own sense of style and her highly developed eye to bear in the new exhibition, and she presents the eighteenth century as it was — intimate, intriguing, and splendid.

Mrs. Vreeland was aided in this endeavor by Stephen Jamail, her special assistant, and by designers Jeffrey Daly and Maureen Healy. Paul Ettesvold, assistant curator in the Costume Institute, performed a crucial role as coordinator of the exhibition and principal author of this publication. Stella Blum, curator of the Costume Institute, was deeply involved in every aspect of the exhibition and in all the careful preparations that surrounded it. Elizabeth Lawrence, master restorer, accomplished with her usual finesse the task of recreating the original silhouette of all the eighteenth-century costumes in the Museum's collection.

Philippe de Montebello
Director
The Metropolitan Museum of Art

The eighteenth-century woman — what made her unique and how does she differ from women of other times?

Women have always been aware of the power of their femininity, but never has womanly wile been applied with such grace, subtlety, and ultimate success as it was during the eighteenth century. With her hips expanded by panniers, waist made small by corsets, and breasts pushed high above a low décolletage, the eighteenth-century woman appeared supremely feminine, submissive, dependent, defenseless. She was, however, a force cloaked in silks, ruffles, fringes, artificial flowers, and laces.

Beyond herself, the woman of the eighteenth century went on to spin a web that included her surroundings. By degrees, she softened and shaped her environment. She made her apartments, salons, and boudoirs, and their furnishings an extension of herself — scaled to her size and decorated to her taste. So persuasive was the charm and grace of the atmosphere she created that men became willing complements to her in appearance, manners, and movements. On easy terms with men, the eighteenth-century woman won their respect and through artful maneuvers and calculated coquetries became a profound influence on the politics, economics, and aesthetics of her era.

In our exhibition, the beautiful costumes of opulent brocades, luxurious satins, and delicate taffetas, along with their exquisite trimmings, help to provide us with an insight into the silken strategy with which remarkable eighteenth-century women molded their century in their own image.

Stella Blum
Curator
The Costume Institute

Introduction

The fortunate few of the eighteenth century dreamed and lived and danced in one of history's most glorious periods. We are, of course, talking of the survivors — who are the only interesting people of any era.

The century burst like a rose and spent itself lavishly, blowing its vitality in a strong and beautiful way all over the Western world. It was a century of quality, artistry, precision, and scholarship. Light, opportunity, and exultation were everywhere. The architecture, the porcelains, the gardens were sublime; every teacup and every flower was very special. The colors were clear and clean — exquisite greens, porcelain pinks, and the wonderful blue that France has always been famous for.

Our own concepts of architecture and decoration were established in the eighteenth century. The interiors, the arrangements of the furniture, and the furniture itself were really all the first bloom of the way we live today, though we live much less lavishly. The comfort with which we live, the way a house is organized, the living in it, and the care of it were all creations of those days. Do you realize what a house was before the eighteenth century? It was huge — enormous and dark — with no halls. You went from room to room to get to a room and suffered drafts and cold.

In the sixteenth and seventeenth centuries women definitely had power — if those around them were powerful and rich. But in the eighteenth century, women often found their way alone and with greater ease, as their talent was recognized and needed. They wrote books; they administered huge estates; they ran small businesses; they created salons where intellect and revolution found a place for expression; they ran convents, which were small worlds where women could live in great protection; and, of course, some women ruled great nations.

Women lived in towns and cities with new privileges. They dressed in the beautiful silks, linens, and muslins that we wear today. They pranced through the minuet, a very special dance that the partners had to know totally, for there was nothing haphazard about dancing — or living — in those days.

This world of the Rococo and the Baroque was also a time of revolution. But revolution is a part of life; it helps convert the possible into the real. And women particularly are always having revolutions of sorts.

Visualize some of the many colorful women, these tireless letter writers and avid travelers of the world:

Lady Mary Wortley Montagu, who journeyed into remote parts of Asia and went twice around the world alone.

The marquise — the beloved Pompadour — who was painted wearing gowns of café-au-lait-colored silk and surrounded by flowers, or in Turkish pants while planning and directing more palaces and gardens and lovely rooms filled with exquisite Sèvres porcelains.

The grand and dignified Georgiana, Duchess of Devonshire, presented to us by Gainsborough walking through her vast estates.

Emma Hamilton, who, while living in Naples, drew all men and women to her feet by her incredible beauty and her amazing postures and poses, through which she became a living work of art.

The Marquise du Châtelet — beautiful, erudite — who read and wrote both Latin and Greek and was mistress of the beloved Voltaire. They say when she visited the king she pointed her nipples with two large rubies — much to her sovereign's delight.

And all the while, Catherine, empress of all the Russias, was buying entire libraries and great collections of art — creating an empire for the land she adopted with such grace and passion.

These women lived in a world of promise, optimism, and possibility. They had their dreams — as all women of all times have had — but they dreamed of a world of independence and privilege, and proceeded to create it themselves.

Diana Vreeland
Special Consultant
The Costume Institute

The Eighteenth-Century Woman

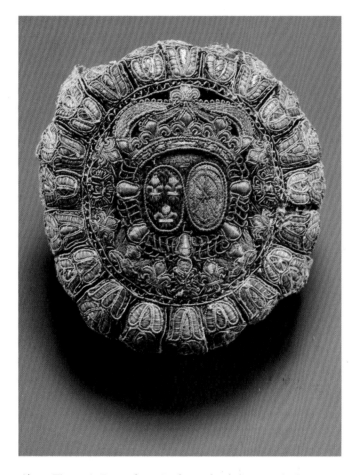

Above: Figure 1. Base of gaming bag. Blue velvet couched in gold and silver threads with the royal arms of France and Navarre. The small *L* between the cartouches may stand for Louis XV. French, mid-eighteenth century. The Metropolitan Museum of Art. Gift of Mrs. Edward S. Harkness, 1930. 30.135.178

Opposite. Figure 2. *Left*: Olive-green silk day dress (*casaquin* and petticoat). Italian, about 1740. The Metropolitan Museum of Art. Rogers Fund, 1926. 26.56.47a–g. *Right*: Blue and silver brocaded afternoon dress (*robe volante*). French, about 1730. The Metropolitan Museum of Art. Gift of the Estate of Annie-May Hegeman, 1950. CI 50.40.9

The memoirs of survivors of the French Revolution are filled with nostalgia for the lifestyle of beauty and elegance that had been destroyed by the mobs. Even Talleyrand, who went on to have a glorious career under Napoleon, once said that no one who had not experienced the *ancien régime* could realize how pleasant it had been. Today one need only visit the galleries of any major museum to become familiar with the paintings and porcelains made for the favorites of the Rococo kings. Period rooms with their carved boiseries and gilded furnishings invite the viewer to imagine himself in those settings. Portraits of court beauties and statesmen give one these people's physical likenesses, just as memoirs and journals regale readers with anecdotes of the writers' daily lives. Although art and literature tell us a great deal about the eighteenth century, for many people they are removed from the human element; it is sometimes difficult to imagine that a Sèvres coffee service exhibited in a vitrine was used in daily life. The art form that possibly reveals the most about what people were like in the eighteenth century is costume. Of all the decorative arts, it is the most comprehensible to everyone, for, although fashions change, the choices and necessities involved in dressing oneself are experienced by everyone daily.

During the reign of Louis XIV (1643–1715) France consolidated her role as the international leader of fashion, a distinction that has only recently been seriously challenged. The ostentation displayed at the Palace of Versailles, where the Sun King assembled his nobility in indolent splendor, set the tone for the succeeding regimes. The shrewd policies of the king's finance minister, Jean-Baptiste Colbert, promoted the textile and luxury trades, establishing French fashion on a solid foundation that has outlasted wars and governments for almost three hundred years. The eighteenth century was a period of unbridled luxury and hedonism mixed with great economic prosperity and radical philosophical ideas. Although France was the wealthiest country in Europe, she experienced, as the century progressed, a gradual weakening of her colonial empire and a decline in her position in international affairs. Members of society, however, were not concerned with matters of policy; their primary occupation was the pursuit of a life of wit and style — an escape from boredom at all costs.

From Lisbon to St. Petersburg, aristocrats and the newly rich bourgeoisie were ardent Francophiles who

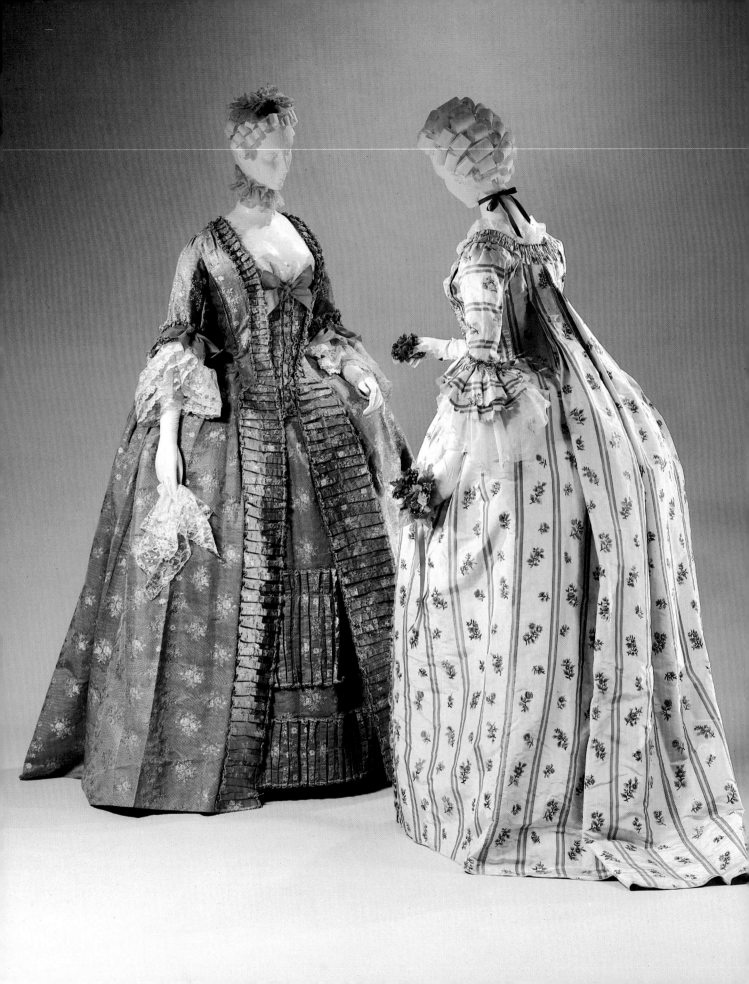

avidly followed French fashions. They were prepared to spend a great deal of money on their clothes, their motto being, "Thy habit should be as costly as thy purse can buy." The cost of clothes in the eighteenth century lay almost entirely in materials; tailoring and the construction of dresses was still a rather elementary business and represented only a small part of the total cost of a man's suit or a lady's court dress. Most of the fabrics we are familiar with today — with the obvious exception of man-made fibers — were in use in the eighteenth century. Cotton was the most revolutionary textile. It began as a luxury fabric and became universally available by the end of the century. The Industrial Revolution in England introduced a number of inventions that helped to ease the production of textiles throughout Europe: the flying shuttle (1733), the spinning jenny (1765), the power loom (1785), and improved knitting machines. Costume also gained a wider range of colors and tints because of strides in the sciences of optics and color.

By our standards, women's fashions in the eighteenth century evolved very slowly. The fabrics, colors, and elaborate trimmings changed often, but the basic sculptural form of the dresses women wore stayed practically the same for years at a time. Four basic silhouettes predominated: the narrow bustle gown of the late seventeenth century; the flowing sacque gown with cascading rear pleats, which prevailed from about 1720 to 1770; the English-inspired fashions of the 1770s and 1780s with their fitted backs; and the classically inspired tubular gowns of the last decade. The shape of the cuff could be changed, the neckline could be altered, and panniers or hoops could be slightly modified without changing the basic dress, which was constructed either as one piece or, more often, as an overdress and petticoat. The shape of the torso was achieved with the aid of a tightly laced cone-shaped corset that pushed the breasts up and forward. A sturdy linen chemise, with trimmings of lace or ruffles at the neckline and cuffs, was worn underneath. Drawers, or *caleçons*, were generally worn only by old ladies out of prudishness or for extra warmth. Heavy petticoats also helped to fight the chill and to support the overdress.

Louis XIV loved splendor, magnificence, and extravagance in all things, and he inspired his whole court to indulge in luxuries — especially clothing. His morganatic wife, Madame de Maintenon, attempted to reform the fashions at Versailles in the 1680s after her preference for somber colors and modest necklines. She was followed in these tastes by older women, but the younger ones rebelled and exaggerated the shapes of their dresses. The bodices were tight and narrow, with a split overskirt drawn back and pinned up over a hip pad or *cul de Paris*. The cone-shaped petticoat thus revealed was riotously trimmed with flounces and embroideries, most often applied horizontally. These gowns must have been heavy and tiresome to wear for long periods. The narrow look of this costume was further emphasized by tall ribbon-and-lace coiffures called the *fontanges* (Figure 4). A minor mistress of Louis XIV, the

Duchesse de Fontanges, disheveled her coiffure while hunting and tied her hair up with her ribbon garters. Considering that the duchess died in 1681, the story may be apocryphal, but, nevertheless, her name was applied to the tall headdress of knotted ribbons and wired lace that predominated for the next thirty years. The wired headdress, worn at a sharp angle off the forehead, was also known as a "commode." The Duc de Saint-Simon in his memoirs remarked that the commode put "the faces of the wearers in the middle of their bodies." The fashion persisted in France until 1713, when a simple, flat head covering worn by an Englishwoman, the Countess of Shrewsbury, caused a sensation and the *fontanges* fell from favor.

With the death of the Sun King in 1715, a radical change occurred in French society. The regent, the Duc d'Orléans, a cultured man and a great lover of the arts, rejected the mien and manner of the conservative old king. He devoted himself to an outburst of high living, which had a considerable effect on aristocratic fashions. Ladies who had been wearing loose negligee gowns in the privacy of their apartments or for casual afternoons in their gardens could now make loose fashions appropriate for general wear. The new sacque dress (Figure 2) hung from the shoulders in voluminous folds, with the extra material at the back gathered into a series of double box pleats. These gowns were variously called *contouches*, *andriennes* (after Terence's comedy *Andria*, in which the leading actress wore a maternity dress), or, later, *robes volantes*. Conservative and prudish older ladies like the dowager Duchesse d'Orléans found the sacque licentious. Here are the duchess's comments in a letter dated December 20, 1721, to her cousin the Princess of Wales:

> The wide skirts which are worn everywhere are my aversion. They look insolent, as though one had come straight out of bed.... The fashion of the beastly skirts first dates from Madame de Montespan. She used to wear them when she was pregnant, so as to hide her condition. After the King's [Louis XIV's] death, Madame d'Orléans revived them again.

The skirts of the sacque were extended by dome-shaped metal or whalebone hoops covered with linen. The introduction of the hoop into France in the first decade of

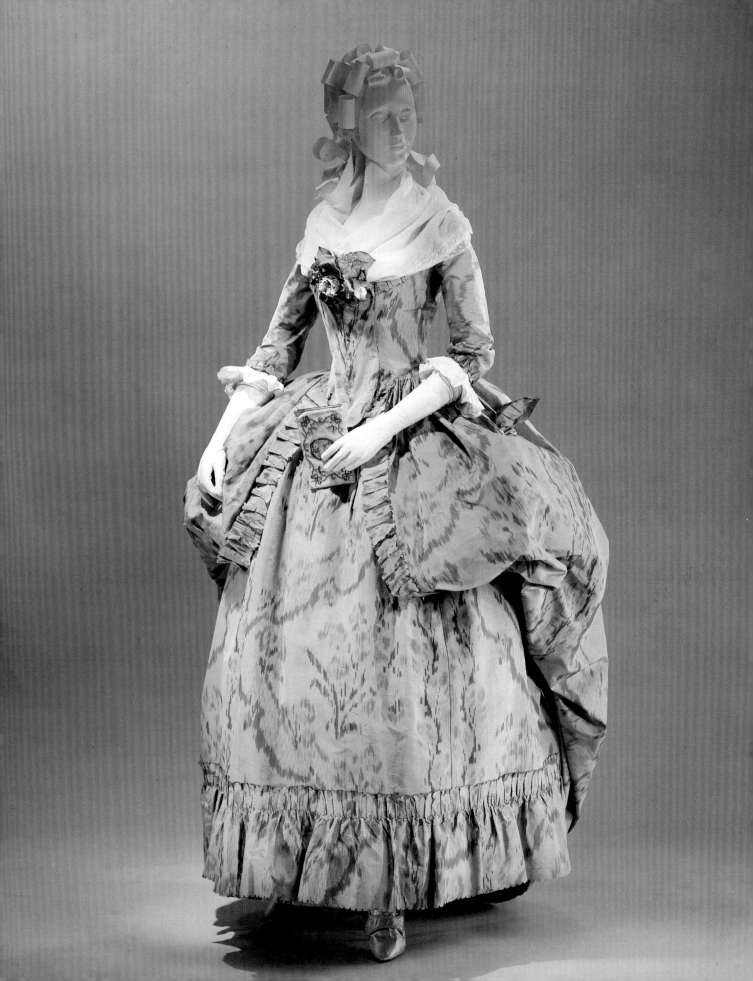

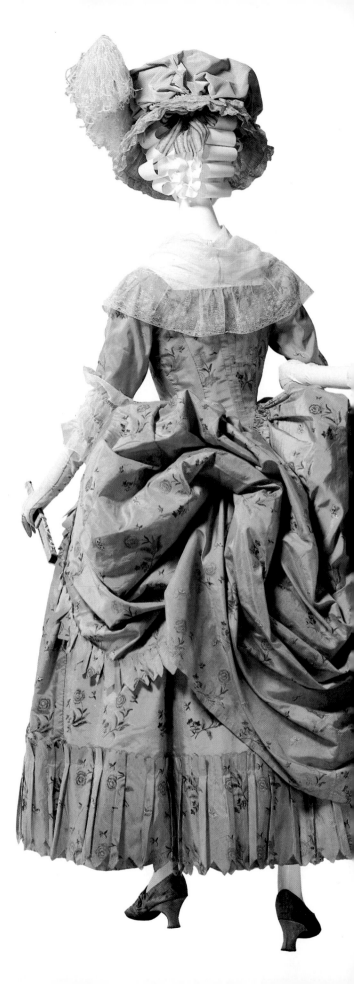

the eighteenth century is credited to either the English or the Spanish. The materials that were lavishly stretched over these hoops were lighter in weight than the fabrics used earlier and were bolder in pattern and color as well.

Over the next twenty years the sacque evolved into the *robe à la française* (Figure 3). It was popularized by Madame de Pompadour and became the most enduring feminine fashion of the eighteenth century. As the style developed, the voluminous folds of the sacque gradually gave way to a defined waistline, which was pulled down into the corset in the front. The pleats at the back were sewn down a few inches from the top and organized into crisp folds. The sleeves were close-fitting to the elbow, where the pleated winged cuffs were replaced by overlapping tiers of ruffles that echoed the sleeve ruffles, or *engageantes*. In time, hoops became even more exaggerated, and elliptical in form instead of round. Trimmings of lace and ruching and passementeries were concentrated at the neckline, down the front opening of the dress, at the sleeve ruffles, and across the front of the exposed petticoat. A ladder of ribbon bows called an *eschelle* covered the stomacher, and ribbons were also worn on the sleeves, around the neck, and in the low, curled coiffure.

With the ascension of Louis XVI to the throne of France in 1774, women's fashions entered a cycle of innumerable changes. This was sparked by the extreme youth of the sovereigns and their intimates, who were tired of the formal *robe à la française* and desired to create new silhouettes with an element of fantasy. Anglomania, which had already affected men's clothes and the cut of ladies' riding habits, reached its greatest heights not only in fashion, but in the design of the carriages, pavilions, and gardens of the late eighteenth century. There was a return to a simpler, more primitive or natural life based on the writings of the *philosophes*, especially Jean-Jacques Rousseau.

The *robe à l'anglaise* (Figure 10), with its fitted back and curved sides following the natural line of the corseted waist, replaced the *robe à la française* for all but the most formal occasions. The bustle, seen in the early years of the century, returned to extend the back of the skirt, which was balanced by a scandalously low neckline, often covered with a plumped *fichu* that created the effect of a pouter pigeon. The skirt was worn short enough to expose the feet and ankles, a fashion that may have

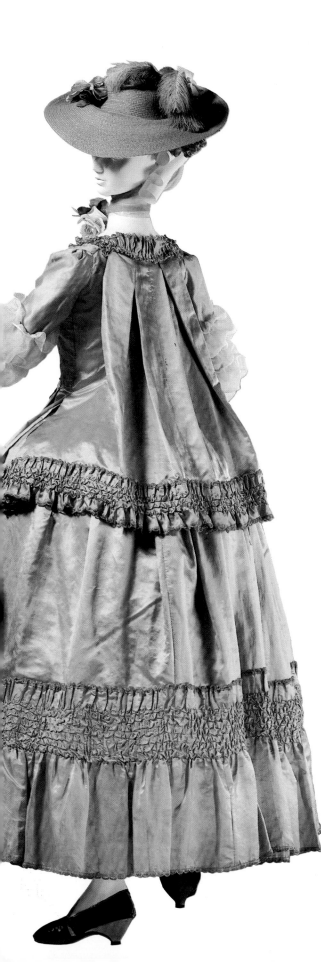

Figure 7. *Left*: Yellow China silk taffeta walking dress (*robe à la polonaise*). American, about 1778. The Metropolitan Museum of Art. Gift of the Heirs of Emily Kearny Rodgers Cowenhoven, 1970. 1970.87ab. *Right*: Yellow satin walking dress (*caraco and petticoat*). French, about 1775. The Metropolitan Museum of Art. Gift of Irene Lewisohn, 1937. CI 37.57ab

originated with the ballet dancer's costume *à la Camargo*. If the skirt of the overdress could be pulled up on the inside by tapes to create a triple swag, the dress was known as a *robe à la polonaise* (Figure 7). (Costume historian François Boucher suggests that this term derives from the tripartite division of Poland in 1772.)

Another fashion popular in the last quarter of the century involved a hip-length bodice, or *caraco* (Figure 7), and a separate skirt. For daywear, the redingote dress, with its long sleeves and collar with revers borrowed from the tailored riding coat, was another fashion alternative. There was also a *lévite*, a long, straight morning gown secured at the waist by a loosely draped sash. Its name came from the costume of a Jewish cleric in a Théâtre Française production of Racine's *Athalie*.

As each new fabric, color, and garment appeared, it was given a fanciful name taken from the theater, current events, literature, music, or perhaps the country from which the French adopted it. For example, the color puce was named by Louis XVI, who thought it looked like the color of fleas! The trimmings of lace, fringe, silk flowers, ribbon, and metallic braid were also subject to the caprices of the fashion leaders and were changed at an alarming rate.

For the fashionable woman, having her hair dressed was one of her most important rituals and one that was very time-consuming. Hairstyles also reflected the events of the era and assumed enormous proportions in the reign of Louis XVI. Ladies wore towering replicas of sailing ships in their hair to celebrate the victory of the warship *La Belle Poule* on June 17, 1778, during the American Revolution. Sentimental *poufs* in the simple style endorsed by Rousseau were also popular; some of them represented pastoral scenes complete with farm buildings, cattle, and tiny people.

The French Revolution completely overturned society, and fashions became politically symbolic. It was dangerous to appear in public in silks and velvets, while the red, white, and blue cockade was the badge of a good *citoyen*. After the emotional strain and deprivations endured during the Reign of Terror, the French were ready to forget their problems and to celebrate the future. They turned to the styles and philosophy of the Greeks and Romans, a society completely different from the one they had just destroyed. The neoclassical current had been growing since the discovery of the ruins of Herculaneum

13

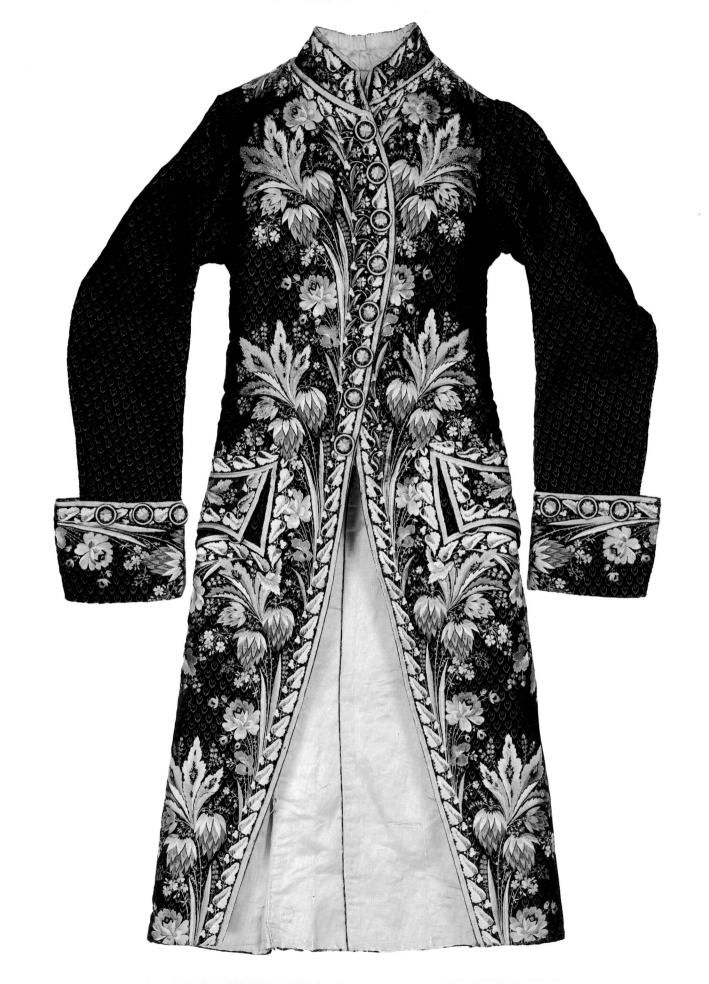

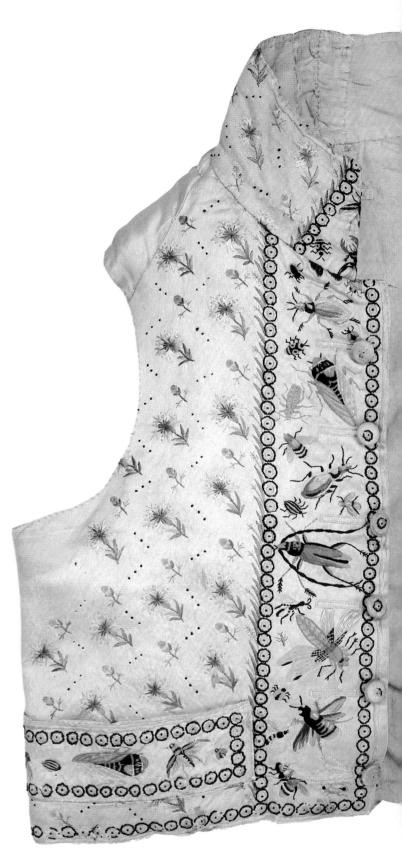

in 1738 and the excavation of Pompeii in 1749. The "classical fever" infected the major and the minor arts in the late Louis XV and the Louis XVI periods. Many fashionable hairstyles, accessories, and costumes were called "à la Greque," although most of them bore little relationship to the ancient styles.

The strongest classical influence showed in the popularity of white linen or cotton gowns (Figure 10). This was a fashion in the English taste that was popularized by Marie Antoinette and her ladies as early as 1778. According to the painter Madame Vigée-Lebrun, "the princesses were not remarkable when seated on the benches, being dressed in cambric muslin gowns, with large straw hats and muslin veils, a costume universally adopted by females at that time." The classical styles of the late nineties had slowly evolved out of the costumes of the previous two decades, with inspiration coming from the historicizing costumes in the paintings of Peyron and David and from the classically costumed actors like Lekain or Mademoiselle Clairion.

The "chemise dress" was basically a tube with a drawstring at the neckline, another at the high waistline, and short sleeves. The bustle continued to be worn for a number of years, but it was positioned higher as the waistline rose. Eventually the bustle disappeared and a train swept along the ground behind the wearer. Sandals, antique-style jewelry, Kashmir shawls, and classically curled hairstyles completed the ensemble.

Men's costumes did not undergo the same great changes in the eighteenth century. The essential components of today's man's suit were established during the reign of Louis XIV. They were a coat, a waistcoat, and knee breeches, which were worn with a white linen shirt with a ruffled front (*jabot*) and a pleated neckband (*rabat*). The general lines of this costume became simplified as the century progressed, so that the early silhouette bears little relation to the suit worn during the Directoire period (1795–99).

The areas of change in men's clothing were principally the coattails (Figure 8), the length of the waistcoat, the shape of the cuffs, and the types of fabrics employed. Coattails and cuffs became successively smaller, and the hem of the waistcoat rose from the knees to the waistline. Fabrics for men's clothes were similar to those used for ladies' dresses in the first half of the century: damasks, corded silks, and velvets for dress wear and gold and silver brocades for state occasions. Elaborate

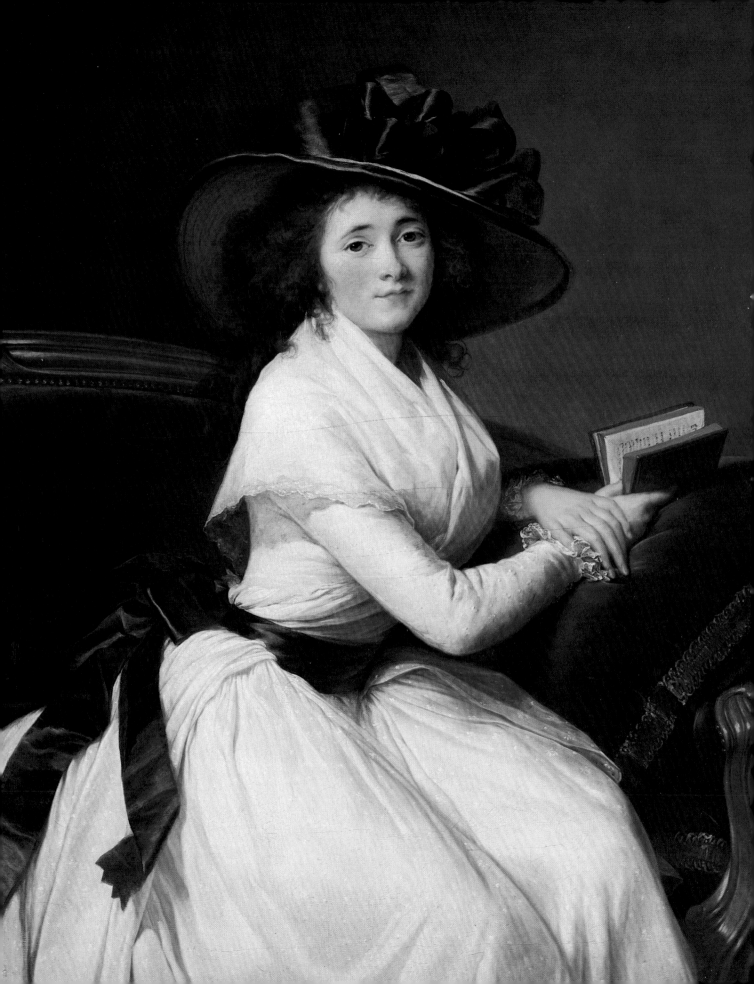

Figure 10. Madame de la Châtre, by Elisabeth Vigée-Lebrun. Oil on canvas. French, late eighteenth century. The Metropolitan Museum of Art. Gift of Jessie Woolworth Donahue, 1954. 54.182

embroideries along the borders of the garments (Figure 8) and special buttons enriched the ensemble. The decoration used on the coat and waistcoat had become restrained by the 1770s, and the fabrics used for daywear became simpler and lighter in weight. One new addition to the male wardrobe was the frock coat, or *frac*, which was worn with a contrasting waistcoat and breeches and was the forerunner of the modern sports jacket.

For most of the eighteenth century, children were dressed like miniature adults, complete with powdered wigs and tightly boned corsets. It was the new attitudes expounded by Jean-Jacques Rousseau in his book *Emile* (1762) that freed children from the constraints of adult costume. Rousseau had been influenced by John Locke's work *Thoughts on Education*, in which the author condemned the confining of children in swaddling clothes or other restrictive attire. Little girls were now given simple frocks of linen or muslin girded at the waists with wide, colorful sashes. Little boys wore skirts until they were "breeched" at age five or six; then they were put into short jackets and pantaloons or trousers, the latter being taken from the common wear of sailors and peasants. The new children's fashions foreshadowed the adult fashions that emerged later in the century.

The eighteenth century was very feminine in its character, for it was an age when women were deeply involved in every facet of the arts, politics, and letters. If a woman was in society, one of her chief concerns was her wardrobe. Being a fashion leader required a fortune — or at least good credit — and, above all, distinctive taste. Unlike women of today, who can rely on their couturiers to present completed models, eighteenth-century women had to direct personally the fashions they wore. In consultation with her tailor or milliner a lady chose fabrics and trimmings and created a design for a desired costume. By the end of the century, a few fashion journals were in circulation and a small group of designers were beginning to assume a creative and dictatorial role over fashion. Rose Bertin, Quinault, Baulard, and Sarrazin were rivals for the patronage of society and the court, and anecdotes of their fads and follies are recorded in the memoirs of the period. Unfortunately, we cannot attribute any surviving costumes to these designers' ateliers, as their works were not labeled.

Three women dominated French fashion and thus the fashion of Europe in the eighteenth century: the Marquise de Pompadour and the Comtesse du Barry, both mistresses of Louis XV, and Queen Marie Antoinette, wife of Louis XVI. Of the three, Madame de Pompadour was the most enlightened patron and set her mark so firmly on the Louis XV style that it is often called *le style Pompadour*. She surrounded herself with the finest art objects of the age — clothes, books, jewelry, porcelain, and furniture. There was scarcely an eighteenth-century artist, poet, or philosopher of the first rank whom she did not patronize lavishly. She imposed her exquisite taste on the court, redecorating the royal apartments and châteaus all with the same touch of natural and delicate gaiety. Madame du Barry learned from her predecessor to employ only the best artists, which was fortunate, as she had a *nouveau riche* taste for ostentation. However, in her day, when conspicuous splendor was the fashion, Madame du Barry's residences and gowns were considered magnificent.

Marie Antoinette had neither the beauty nor wit of the previous fashion arbiters, and she did not understand the responsibilities of her position. At times it seemed the only title she valued was that of fashion leader. Her influences on the decorative arts are best seen at the Petit Trianon, with its classic interior and exotic gardens, and in her considerable wardrobe. Marie Antoinette's taste vacillated with each new fad. With the help of her milliners and hairdressers, the young queen created fashions that were imitated by most other women and were ruinously expensive for all concerned.

The constant search for something new and wondrous reveals a skepticism that pervades eighteenth-century ideas. La Bruyère in the sixth edition of his *Les Caractères* (1691) dryly anticipated the endless cycle of fashion changes:

A fashion has no sooner supplanted some other fashion than its place is taken by a new one, which in turn makes way for the next, and so on; such is the fickleness of our [French] character. While these changes are taking place, a century has rolled away, relegating all this finery to the dominion of the past.

Yet, despite the continually changing fashions, the quality and beauty of the surviving eighteenth-century costumes are all the justification one need proffer in their defense.

Bibliography

Buck, Anne. *Dress in Eighteenth-Century England*. London, 1979.

Christensen, Sigrid Flammand. *Kongedragterne Fra 17, og 18 Aarhundrede*. Copenhagen, 1940.

Contini, Mila. *Fashion from Ancient Egypt to the Present Day*. New York, 1965.

Cunnington, C. Willet and Phillis. *Handbook of English Costume in the Eighteenth Century*. London, 1964.

Davenport, Millia. *The Book of Costume*. Vol. II. New York, 1948.

De Afrasio, Roger, and Charles, Ann. *The History of Hair*. New York, 1970.

Fletcher, Marion. *Costume and Accessories in the Eighteenth Century*. Melbourne: National Gallery of Victoria, 1977.

Johnson, Allen. *Dictionary of American Biography*. New York, 1929.

Kroll, Maria. *Letters from Liselotte*. New York, 1971.

Lacroix, Paul. *The XVIIIth Century: Its Institutions, Customs and Costumes. France, 1700–1789*. London, 1876.

La Tour du Pin, Marquise de. *Journal d'une femme de cinquante ans*. Paris, 1914.

Luynes, Duc de. *Mémoires sur la cour de Louis XV (1735–1758)*. 17 vols. Paris, 1860.

Mercier, Louis-Sébastien. *Tableau de Paris*. Amsterdam, 1783–88.

Molesworth, H. K. *The Golden Age of Princes*. New York, 1969.

Moore, Doris Langley. *The Child in Fashion*. London, 1953.

Musée du Costume de la Ville de Paris. *Elégances du XVIIIᵉ siècle costumes français 1730–1794*. Paris, 1963.

Payne, Blanche. *History of Costume*. New York, 1965.

Poignant, Simone. *Les Filles de Louis XV l'aile des princes*. Paris, 1970.

Saint-Simon, Duc de. *Mémoires*. Edited by M. Chéruel. Paris, 1900.

Varron, A. "Children's Dress," *Ciba Review* 32 (April 1940).

Vigée-Lebrun, Elisabeth. *Memoirs*. Translated by Lionel Strachey. New York, 1903.

Waugh, Norah. *The Cut of Women's Clothes 1600–1930*. New York, 1968.

Zwieg, Stefan. *Marie Antoinette: The Portrait of an Average Woman*. New York, 1933.

Figure 11. Queen Maria Leczinska, by Louis Toqué. Oil on canvas. French, 1740. Lent by the Musée National du Château de Versailles. SL 81.82.2

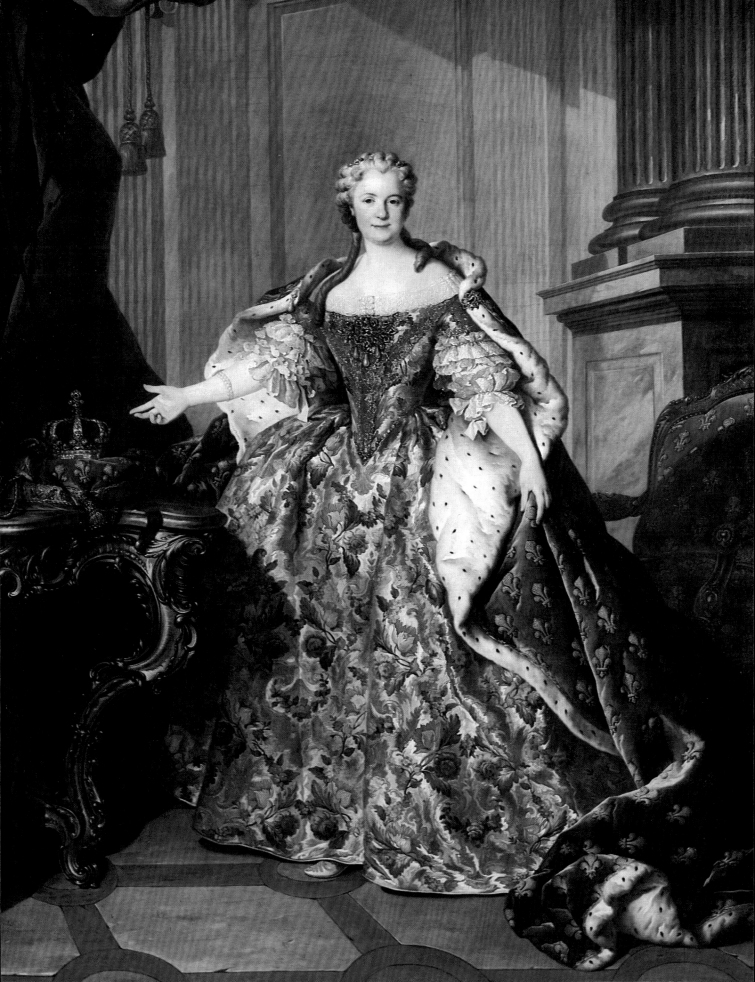

Checklist of the Exhibition

WOMEN'S COSTUMES

Formal Dress
Taupe-colored wool striped in mustard, pink, henna, and indigo blue, with silver-gilt embroidery in a conventionalized flower-and-scroll pattern
English, about 1690
The Metropolitan Museum of Art
Rogers Fund, 1933
33.54ab

This gown, one of the finest surviving seventeenth-century costumes, is the most important European costume in the Museum's collection. Though worn by a lady of the Wodehouse family of Kimberley House, Norfolk, the dress is French in cut, with its straight skirt drawn in at the waist and its fitted bodice looped up at intervals at the sides and held with small gold pins. The dress was supported by a bustle or *tournure*, which concentrated the fullness at the center back. Similar gowns can be found in the dated Nicolas Arnoult costume plates, although those examples are elaborately embroidered. The English love of embroidery can be seen not only in costume and accessories of this period, but also in the upholstery and wall hangings with which homes were decorated. An engraving of Mary II by I. Smith after a portrait by Vandervaart shows a similar dress. The very early use of a foliate *rocaille* pattern and the technical quality of the embroidery indicate that this dress is the work of a professional embroiderer aware of the latest artistic currents on the Continent — possibly one of the Huguenot refugees who settled in England after the revocation of the Treaty of Nantes in 1685.

Jacket (casaquin)
Quilted white linen embroidered with polychrome silks in a floral and ribbon pattern, edged and laced under the sleeves with yellow silk ribbon
Swedish, late 17th century
Lent by the Nordiska Museum, Stockholm
SL 81.91.6a

In the eighteenth century aristocratic Swedish ladies wore quilted jackets and contrasting petticoats at home during the long winters. Many of these garments were embroidered by the ladies themselves, and all were in bright colors, which helped to keep the spirits up during months of cold and snow.

Jacket (casaquin)
Dark brown silk damask trimmed with silver braid, foliate embroidery in salmon-pink silk and silver metallic threads, silver metallic buttons, and silver lace, with cuffs of pale blue, tan, and cream silk floral brocade edged with coral and white silk ribbon
Italian, 2nd quarter of 18th century
The Metropolitan Museum of Art
Purchase, Catherine Breyer Van Bomel Foundation Gift, 1981
1981.2107

In the first half of the eighteenth century, ladies wore *casaquins* and petticoats for daywear as an alternative to the formal *robe à la française*. The *casaquin*, or jacket, was cut like a dress but came only to the hip. Usually the skirt was of a contrasting material or color and ended at the ankles. This popular costume was the basic ensemble for ladies of the bourgeoisie and for servants. This Italian *casaquin*, once in the Simonetti Collection, Rome, is an elaborate example of the style, which enjoyed great popularity in Italy and is often seen in contemporary paintings. The contrasting silk cuffs rounded at the edges were pinned back in imitation of gentlemen's cuffs of about 1725. The back of the costume is fitted.

Formal Dress (robe volante)
Polychrome lace-pattern silk brocade on an ivory-colored ground in a floral, foliate, and gourd design; stomacher embroidered with multicolored silks and silver and gold metallic thread in a floral and gourd design, edged with silver and gold metallic lace
French, about 1725
Lent by the Musée des Arts Décoratifs, Paris
SL 81.84.lab

Afternoon Dress (robe volante)
Pale blue and silver mirror-silk brocade in
 a large floral and foliate pattern
French, about 1730
The Metropolitan Museum of Art
Gift of the Estate of Annie-May Hegeman,
 1950
CI 50.40.9
Illustrated, page 7

Late in the reign of Louis XIV, loose-
flowing gowns with pleats gathered at the
back neckband were worn as undress wear
by daring ladies who liked the ease and
comfort of this garment. The famous
actress Madame Dancourt popularized
these gowns by wearing one in Terence's
Andria, after which such gowns were
often called *andriennes*. As the style
developed the gathers were formalized by
being drawn into one or more flat pleats,
and a dome-shaped hoop or pannier was
worn to extend the material around the
wearer. When a lady moved, air was
trapped under the hoops and she appeared
to be floating; thus the name *robe volante*.
This type of dress is often erroneously
called a "Watteau sack," despite the fact
that Antoine Watteau had little to do with
the creation or dissemination of the fashion.
According to the *Mercure de France*, by
1729 *robes volantes* were "universellement
en règne, on ne voit presque plus d'autres
habits" (universally in vogue, one hardly
ever sees any other kind of dress).

Formal Dress (closed robe)
Brown satin with a lace pattern in beige
 and orange silks
English, about 1735 (remade later)
The Metropolitan Museum of Art
Purchase, Irene Lewisohn Bequest, 1964
CI 64.14

The closed robe was popular in England in
the second quarter of the eighteenth
century. It had a close-fitting bodice,
deeply set sleeves with small winged cuffs,
and short, flat robings. The attached skirt
was made with a short center fall gathered
at the waistband and tied behind the waist
inside the bodice. A dome-shaped hoop or

pannier of canvas, wicker, or buckram
supported the heavy brocade skirt. A
modesty piece edged with a lace "tucker"
was generally worn to hide the chemise.

Day Dress (casaquin and petticoat)
Olive-green silk in a white floral pattern
Italian, about 1740
The Metropolitan Museum of Art
Rogers Fund, 1926
26.56.47a–g
Illustrated, page 7

Afternoon Dress (robe à la française)
Cream-colored figured silk brocaded with
 polychrome silks in an allover floral
 pattern, trimmed with self-fabric ruching
 and green and coral braid
French, about 1740
Lent by the Musée de la Mode et du
 Costume, Paris
SL 81.83.2ab

Petticoat
Quilted green silk embroidered at the hem
 with yellow and white silks in a floral,
 foliate, and *rocaille* border, with a
 waistband of blue, white, and black
 braid
Swedish, about 1750
Lent by the Nordiska Museum, Stockholm
SL 81.91.6b

Riding Coat
Dark brown camlet with attached vest of
 light blue satin and matching collar and
 cuffs, trimmed with gilt cord and brass
 buttons
English, about 1750
The Metropolitan Museum of Art
Purchase, Mr. and Mrs. Alan S. Davis
 Gift, 1976
1976.147.1

Riding habits for ladies made their
appearance during the reign of Charles II.
They were modeled on the male coat and
waistcoat and were worn over a shirt or
petticoat. This riding coat is made of
camlet, a fine fabric of mixed materials
including wool, silk, and goat or camel's

hair. The closely woven fabric is nearly
waterproof, an important consideration in
the English climate. The name "camlet"
derives from either "camel hair" or the
fabric's place of manufacture on the river
Camlet in England.

Day Dress (open robe and petticoat)
Blue silk satin quilted in an allover pattern
 of squares interspersed with floral motifs
English, about 1750
The Metropolitan Museum of Art
Purchase, Irene Lewisohn Bequest, 1981
1981.152a–e

Formal Dress (closed robe)
White satin brocaded in shades of red and
 green in a pattern of leaves and flowers
 with ogival stems
English, about 1750
The Metropolitan Museum of Art
Rogers Fund, 1936
36.145

The suburbs of London, near Bishopsgate,
were the scene of a thriving silk industry
from the early eighteenth century on. The
cloth, used principally for dress material,
was made by journeymen weavers in an
area called Spitalfields, a name that became
synonymous with the silks produced there.
Working in a dynamic fashion center so
close to the London marketplace, the
designers of Spitalfields silks changed their
patterns often. In the 1750s, when this
dress was made, the silks were patterned
with garden flowers arranged on an open
ground in curving Rococo forms. The wide
hoops then in fashion would have shown
these materials to good advantage.

Ball Gown (robe à la française)
Cloth of silver with stripes of blue silk and
 gold tinsel, brocaded multicolored
 bouquets and chinoiserie motifs, and
 trimmings of metallic lace and
 polychrome silk ribbon rosettes
French, about 1755
The Metropolitan Museum of Art
Gift of Fédération de la Soirie, 1950
CI 50.168.2ab

Ladies of fashion changed their costumes several times a day, but their most splendid gowns were reserved for the evening — for going to dinner, to the opera, or perhaps to a ball and a late supper. A ball gown of this quality would have been reserved for truly ceremonial occasions. The cloth of silver is brocaded with chinoiserie motifs of a curved palm tree and a pagoda interspersed with floral bouquets in the style of Jean Pillement. The silver lace and twisted silk flower trimmings show the milliner's art at its most elaborate. French guild laws restricted the cutting and sewing of formal dresses to a male tailor and his assistants, but a milliner could trim gowns as well as make headpieces. Louis-Sébastien Mercier, in his *Tableau de Paris*, made the following observation on the collaboration of men and women fashion workers: "The seamstresses who cut and sew the dresses and the tailors who make the stays and corsets are the masons of the edifice, and the *marchand de modes* who creates the accessories that give the final graceful touches is the architect and decorator."

Day Dress (robe à la française)
Light salmon-colored silk taffeta with a *chiné* floral pattern in shades of pink, green, and brown; self-fabric trim
French, about 1755
The Metropolitan Museum of Art
Gift of Fédération de la Soirie, 1950
CI 50.168.lab

Chiné taffetas were produced in France in quantity beginning in the second decade of the eighteenth century. They were "in imitation of the Indian and Levantine" fabrics — many of them ikats — that were imported into Europe to satisfy the taste for orientalism. Many *chiné* garments were also called *à la turque*. The colored floral patterns were achieved by dyeing the warp threads before the fabric was woven. This intricate and cumbersome process naturally made the fabric very expensive. Even though the technical process is explained in contemporary trade journals, modern fabric manufacturers have not been able to recreate the finest *chiné* patterns.

Formal Dress (robe à la française)
Blue patterned silk brocaded with polychromed silks in a floral and fruit pattern, trimmed with self-fabric ruching edged with matching ribbon fly fringe
Italian, about 1755 (fabric about 1735)
The Metropolitan Museum of Art
Bequest of Catherine D. Wentworth, 1948
CI 48.187.709ab

Afternoon Dress (robe à la française)
Green and white patterned silk with foliate meander interspersed with floral buds, trimmed with self-fabric ruching edged with matching braid
French, about 1757
The Metropolitan Museum of Art
Gift of Mrs. Robert Woods Bliss, 1943
CI 43.90.49

Evening Gown (robe à la française)
Light blue ribbed silk brocaded with polychrome silks and gold and silver metallic threads in floral and foliate motifs, trimmed with self-fabric ruchings edged with matching fly fringe
French, about 1758
The Metropolitan Museum of Art
Purchase, Irene Lewisohn Bequest, 1962
CI 62.28ab
Detail of fabric illustrated, page 27

Wedding Dress (mantua, petticoat, and court train)
Light blue *cannelé*-woven silk embroidered with polychrome silks in a floral and foliate pattern, with a gold silk lace and *rocaille* meander pattern, trimmed with pale pink braid
Dutch, 1759
Lent by the Rijksmuseum, Amsterdam
SL 81.93.a–c

In 1759, at age twenty-two, Helena Slicher married Baron Aelbrecht van Slingelandt wearing this blue silk *grand panier* gown. The wedding must have been very elaborate, for no expense or effort was spared in the construction of this superb gown with its mantua, petticoat, and rounded train. The elaborately embroidered borders in gold silk *rocaille* patterns and the polychrome silk flowers, including the Dutch tulip, were probably the work of Dutch embroiderers, though the designs are heavily influenced by French models. This is one of the finest surviving dresses of its kind, the only similar one being a 1744 wedding dress in the collection of the Victoria and Albert Museum, London. Jonkvrouw Catharina Isabella Six presented this wedding dress to the Rijksmuseum in 1978. A descendant of the bride, she inherited the dress from her uncle, Higibert Chrétien Bosch-Reitz, curator of the Department of Far Eastern Art at The Metropolitan Museum of Art from 1915 to 1927.

Formal Dress (robe à la française)
Azure-blue satin trimmed with self-fabric ruching in a punched design
English, about 1760
The Metropolitan Museum of Art
Bequest of Mrs. Maria P. James, 1911
11.60.232ab

A formal dress was not considered finished until it had been trimmed with robings along the opening of the bodice, down the skirt front, and along the edges of the pagoda sleeves. Robings of gauze, ribbons, fringe, or silk flowers were supplied by a milliner and could be very expensive, as they were complicated and time-consuming to make by hand. Further, ladies would update their gowns from season to season by changing the robings. This particular dress substitutes for fancy robings self-fabric ruching with a punchwork pattern and pinked edge, made with an awl and a sharp rolling wheel much like a pastry cutter. The National Gallery of Victoria, Melbourne, has a similarly trimmed dress in bright canary-yellow corded silk, and examples can be found in British and American Colonial portraits.

Evening Gown (robe à la française)
Lavender silk faille with brocaded floral bouquets in polychrome silks alternating with an ivory lace-and-flower meander, trimmed with multicolored fly fringe, ribbon ruching, and small silk flowers
French, about 1760
The Metropolitan Museum of Art
Purchase, Irene Lewisohn Bequest, 1959
CI 59.29lab

Day Dress (robe à la française)
Ivory-colored cotton printed with an allover pattern of chinoiserie flowering branches in shades of blue, brown, and red, trimmed with box-pleated self-fabric
French, about 1760
The Metropolitan Museum of Art
Purchase, Irene Lewisohn Bequest, 1964
CI 64.32.3ab

Ball Gown
Beige ribbed silk brocaded with silver-gilt thread and polychrome silks in floral sprays and serpentine meanders, trimmed with gold and silver Cluny-type lace and beige silk ribbon
French, about 1760
The Metropolitan Museum of Art
Gift of Mrs. Hervey Parke Clark, 1961
CI 61.16ab

Figure 12. Two brooches and a pair of earrings. Diamonds and rubies set in silver. Spanish (?) and Portuguese. The Metropolitan Museum of Art. Gift of Marguerite McBey, 1980. 1980.343.5, 6, 7, 17

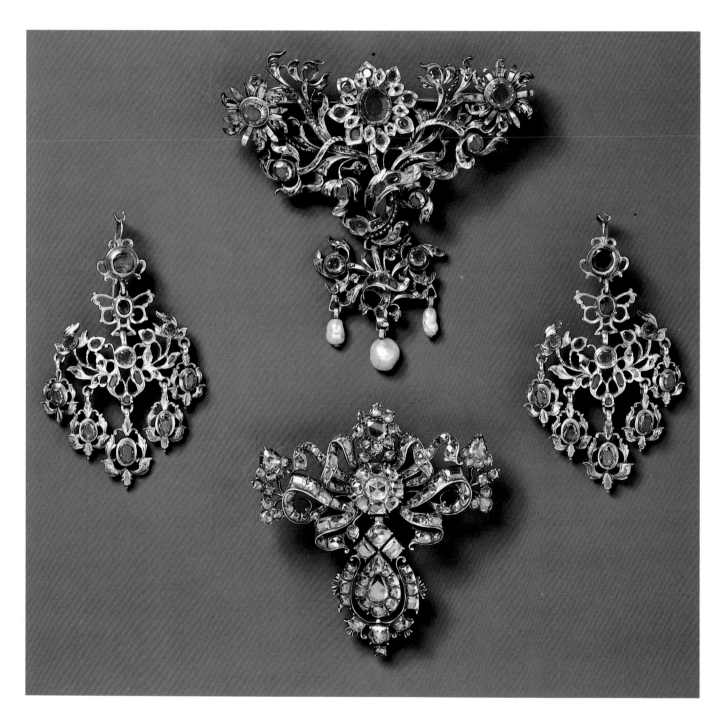

Skirt
Pink satin quilted in a stylized floral
 pattern
English, about 1760
Lent by Cora Ginsburg, Tarrytown, New
 York
SL 81.68.2a

Court Dress (mantua and petticoat)
Delphinium-blue silk self-patterned and
 brocaded with flat and wrapped silver
 thread in a pattern of rosettes
 interspersed with rose sprays,
 carnations, and plumes, trimmed with
 silver lace
English, about 1760
The Metropolitan Museum of Art
Purchase, Irene Lewisohn Bequest, 1965
CI 65.13.la–c

Although the English court did not
dominate fashion as did its French
counterpart, it did require that a special
costume be worn for important state
ceremonies, coronations, and royal
weddings. A court lady wore a mantua and
petticoat of rich silk, often elaborately
woven or embroidered with gold and silver
metallic threads. She further displayed her
wealth by trimming the mantua with fine
laces and wearing a great quantity of
jewelry. In the early eighteenth century a
mantua was a loose gown stitched into
pleats at the back, with the sides of the
skirt pinned up on the hips. By the time
this dress was made, the mantua had
become a fitted bodice with two hanging
vestigial panels at the back, replacing the
side draperies. The petticoats were
extended on exaggerated panniers, a
fashion that was to continue for court wear
long after it had ceased to be a feature of
fashionable dress. A court dress of similar
date can be found in the collection of the
Royal Scottish Museum, Edinburgh.

Ball Gown (robe à la française)
Ivory-colored Spitalfields silk figured with
 satin and ribbed stripes brocaded in
 green and pink silks with ribbon, floral
 vines, and scattered flowers, and
 trimmed with ivory-colored satin-striped
 net and polychrome silk and paper
 flowers
English, about 1765
The Metropolitan Museum of Art
Hoechst Fibers Industries Gift, 1981
1981.351ab

Afternoon Dress (robe à la française)
Pale yellow silk with a white lace pattern
 brocaded in multicolored floral sprays,
 trimmed with self-fabric ruching
English, about 1765
The Metropolitan Museum of Art
Purchase, Irene Lewisohn Bequest, 1975
1975.206.2ab

Afternoon Dress (robe à la française)
Pale fawn-colored silk taffeta with a satin
 stripe and brocaded polychrome floral
 sprays, trimmed with self-fabric ruching
English, about 1765
The Metropolitan Museum of Art
Purchase, Irene Lewisohn Bequest, 1960
CI 60.41.1ab

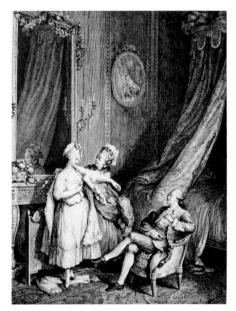

Formal Dress (open robe)
Putty-colored silk ground brocaded in
 polychrome sprays of flowers and fruit,
 trimmed with self-fabric ruching and
 matching fly fringe
English, about 1765 (fabric about 1735)
The Metropolitan Museum of Art
Rogers Fund, 1934
34.108

Afternoon Dress (robe à la française)
Natural linen with crewelwork floral sprays
 and trellis border in yellow, pink, blue,
 and green
French, about 1765
The Metropolitan Museum of Art
Rogers Fund, 1936
36.95ab

Ball Gown (robe à la française)
Rose-colored figured silk brocaded in a
 polychrome design of bands of ermine
 intertwined with floral sprays, trimmed
 with matching braid and multicolored
 fly fringe
French, about 1765
The Metropolitan Museum of Art
Fletcher Fund, 1938
38.30.lab

Ball Gown (robe à la française)
Self-figured white silk brocaded in
 polychrome floral sprays, trimmed with
 self-fabric ruching and multicolored fly
 fringe
English, about 1766
The Metropolitan Museum of Art
Rogers Fund, 1925
25.12ab

Ball Gown (robe à la française)
Beige silk faille brocaded in polychrome
 floral sprays and leopard-spot meander,
 trimmed with pink fly fringe and tassels
French, about 1770
The Metropolitan Museum of Art
Purchase, Irene Lewisohn Bequest, 1961
CI 61.34ab

Evening Gown (robe à la française)
Cream-colored satin-striped silk faille spot
 brocaded with floral sprays and leaves
 in polychrome silks and silver metallic
 threads, trimmed with silver lace
English, about 1770
The Metropolitan Museum of Art
Purchase, Irene Lewisohn Bequest, 1962
CI 62.29.lab
Illustrated, Contents page

Afternoon Dress (robe à la française)
Mauve silk taffeta with paired white bands
 and a *chiné* pattern in shades of red and
 green; self-fabric ruching
French, about 1770
The Metropolitan Museum of Art
Purchase, Irene Lewisohn Bequest, 1960
CI 60.40.2ab
Detail of fabric illustrated, back cover

Formal Dress (robe à la française)
Mimosa-yellow silk faille trimmed with
 matching fly fringe
English, about 1770
Lent by Shannon Rodgers
SL 81.114ab

Ball Gown (robe à la française)
Ivory-colored ribbed silk with stripes of light blue and pink overlaid with serpentine garlands and floral sprays brocaded in polychrome silks, trimmed with self-fabric and multicolored fly fringe
French, about 1770
The Metropolitan Museum of Art
Purchase, Irene Lewisohn Bequest, 1961
CI 61.13.lab
Illustrated, front cover

Formal Dress (robe à la française)
Ivory-colored silk striped in pale green and salmon pink, overlaid with brocaded white and polychrome silk chinoiserie floral sprays, trimmed with ivory gauze and pink and green patterned silk ribbon
French, about 1770
The Metropolitan Museum of Art
Purchase, Irene Lewisohn Bequest, 1968
CI 68.69

Evening Gown (robe à la française)
Green corded silk with a brocade design of rose sprays between undulant flowering vines, trimmed with box-pleated self-fabric bands edged with pink, green, and white braid
French, about 1770
The Metropolitan Museum of Art
Rogers Fund, 1932
32.35.2ab
Illustrated, page 8

Ball Gown (robe à la française)
Yellow silk taffeta striped in white, dark brown, yellow, and pink satin, trimmed with gauze ribbon and floral rosettes.
Austrian, about 1770
The Metropolitan Museum of Art
Gift of Lee Simonson, 1939
CI 39.13.85ab

Afternoon Dress (robe à la française)
Cream-colored satin with rust, yellow, and black stripes, trimmed with self-fabric ruching and cream- and rust-colored braid
French, about 1770
The Metropolitan Museum of Art
Purchase, Irene Lewisohn Bequest, 1966
66.37.2

Bodice of Court Dress
Figured green satin with pink and white silk and silver-metallic stripes and polychrome floral brocade, trimmed with gold and silver lace, polychrome silk ribbon, passementerie, and silk flower buds, with silver metal rear hooks
French, about 1770
The Metropolitan Museum of Art
Gift of Miss Agnes Clarke, 1946
46.42.6

At the court of France, ladies were expected to be in full court dress for all formal occasions. A *dame du palais* or *femme de chambre* who waited on the queen was required to wear full court dress at all times. These dresses had enormous hoops that held out a petticoat ornamented with gold metallic decorations and polychrome silk embroideries. A long train was fastened around the waist and trailed behind the wearer. The bodice, stiffened with whalebone, was completely different from those worn with other dresses. (See illustration on page 19.) The Marquise de la Tour du Pin described one of her bodices in her memoirs:

I wore a *grand corps,* a specially made bodice, without shoulders, laced in the back, but so narrow that the lacing, about four inches wide at the bottom, showed a chemise of the finest batiste through which one could easily have noticed an insufficiently white skin. The chemise had sleeves that were only three inches high, without a shoulder, to leave the neckline bare. The top of the arm was covered with three or four rows of lace, which fell to the elbow. The chest was entirely exposed.

This court bodice is extremely rare, for there are no known examples surviving in France. Full court dresses in cloth of silver cut along the lines of the French court dress are preserved in the Kremlin Museum, Moscow, and in the Royal Armory, Stockholm.

Riding Jacket
Light brown camlet trimmed with self-fabric buttons and military revers
English, about 1770
Lent by the National Museum of American History, Smithsonian Institution, Washington, D.C.
SL 81.92.2

Day Dress (round gown)
Dark brown resist-dyed natural cotton with an allover floral design in light blue and sienna
American, about 1774
The Metropolitan Museum of Art
Gift of Helen MacCartney, 1926
26.38a

Day Dress (robe à l'anglaise)
Ivory-colored silk taffeta with an allover *chiné* V-pattern in red, blue, and yellow, trimmed with olive-green braid
English, about 1775
The Metropolitan Museum of Art
Purchase, Judith and Gerson Leiber Gift, 1981
1981.314.1

Textile historians attribute large-patterned *chiné* taffetas to France. However, small *chiné* designs were produced at other European silk centers, especially in England, where they were called "clouded lustrings." It is tempting to postulate an English origin for this dress's fabric, as well as its tailoring. *Chiné* fabrics were popular for summer dresses because they were lightweight.

Day Dress (robe à l'anglaise)
White linen embroidered with multicolored silks in a pattern of floral sprays, small sprigs, and pots of flowers
English, about 1775
The Metropolitan Museum of Art
Purchase, Irene Lewisohn Bequest, 1966
CI 66.34

Linen gowns, plain versions of contemporary dress, were popular with gentlewomen for morning wear in the English countryside. These gowns were very sensible, as they could be laundered often and still retain a fresh appearance. They were often decorated with embroidery, usually stitched by the wearer herself. Embroidery was considered a gentle, feminine occupation for ladies of all classes of society. The lively floral embroidery on this day dress was probably done from a ready-made pattern, although the embroiderer has individualized the floral bouquets.

Evening Gown (robe à la piémontaise)
Ivory-colored taffeta striped in blue and yellow-gold silk and silver metallic threads, overlaid with floral sprays brocaded in polychrome silks and colored metallic threads, and trimmed with self-fabric ruching edged with matching fly fringe
German, about 1775
The Metropolitan Museum of Art
Gift of Mrs. Leo S. Gold Schmidt, 1961
CI 61.11.

A *robe à la piémontaise* is a variant of the basic *robe à la française*, except that the rear pleats, instead of being attached, float freely from the neckline to the center back. The style is named after a princess of the House of Savoy who wore a gown of this type in Lyons in 1755. Another rare example of this style is in the Rocamora Collection, Barcelona.

Afternoon Dress (robe retroussée dans les poches)
Rose-colored silk taffeta with a *chiné* floral pattern in shades of rose and green; self-fabric trim
French, about 1775
The Metropolitan Museum of Art
Anonymous loan
L 39.29.lab
Illustrated, page 11

On this *chiné* taffeta day dress, the points on both sides of the central opening have been drawn underneath the skirt and pulled through the pocket openings on either side of the hips to create a swagged effect. The *robe retroussée dans les poches* ("dress turned up in the pockets") is a forerunner of the *robe à la polonaise.*

Walking Dress (caraco and petticoat)
Yellow satin trimmed with self-fabric ruching and matching braid
French, about 1775
The Metropolitan Museum of Art
Gift of Irene Lewisohn, 1937
CI 37.57ab
Illustrated, page 13

In the third quarter of the century a new fashion, the *caraco plissé*, became popular. A version of the basic *robe à la française*, it terminated at the hipline and was worn with a matching short skirt. The ladies of Nantes supposedly invented the costume and wore it when they received the entourage of the royal governor, the Duc d'Aigullon. Its ease and coquetry soon made it accepted daywear for ladies of the aristocracy and the bourgeoisie.

Day Dress (robe à la française)
Orange iridescent silk striped in cream, blue, and rust, trimmed with self-fabric ruching edged with matching fly fringe
French, about 1775
The Metropolitan Museum of Art
Purchase, Irene Lewisohn Bequest, 1960
CI 60.39.lab

Day Dress (robe à la française)
Cream-colored silk brocaded in a polychrome design of rose branches and floral landscapes framed in curving palms, trimmed with self-fabric ruching edged with matching braid
French, about 1775
The Metropolitan Museum of Art
Purchase, Irene Lewisohn Bequest, 1960
CI 60.40.lab

Formal Dress (robe à la française)
Deep mimosa-yellow ribbed silk trimmed with self-fabric robings edged in lace
French, about 1775
The Metropolitan Museum of Art
Purchase, Irene Lewisohn Bequest, 1964
CI 64.31.lab

Formal Dress (robe à la française)
Blue satin with an allover floral pattern in gold and ivory, trimmed with self-fabric ruching and matching fly fringe
French, about 1775
The Metropolitan Museum of Art
Gift of Mrs. Robert Woods Bliss, 1943
CI 43.90.48ab

Morning Dress (robe à la française)
White cotton printed with red and blue floral meander and red stripes, trimmed with self-fabric ruching edged with pale pink braid.
French, about 1775
The Metropolitan Museum of Art
Gift of Lee Simonson, 1939
CI 39.13.185a–d

Riding Jacket
Medium blue camlet trimmed with matching buttons
English, about 1775
The Metropolitan Museum of Art
Purchase, Mr. and Mrs. Alan S. Davis Gift, 1976
1976.147.2

Many male critics of social behavior, including Pepys and Addison, disliked the "immodest custom" of ladies wearing masculine attire. The ladies, however, found masculine tailoring not only practical for their sports clothes but alluring as well. A discerning but, alas, anonymous gentleman agreed with them and made the following lively remarks in the weekly *Register* of July 10, 1731:

> The Riding Habit simply, with the black velvet cap and white feather, is in my opinion, the most elegant dress that belongs to the ladies' wardrobe; there is a grace and gentility in it that all other dresses want; it displays the shape and turn of the body to great advantage, and betrays a negligence that is perfectly agreeable.... She who makes her actions most conformable to that standard, will always be most secure of conquests and reputation.

Hooded Cape
Scarlet wool with borders of matching plush; with attached vestee
American, about 1775
The Metropolitan Museum of Art
Purchase, Irene Lewisohn Bequest, 1969
CI 69.4

Cloaks in one form or another were popular items of dress in the American colonies from the time of the early settlers. This particular type of cloak, called a "cardinal" because of its color, is made of a closely woven wool cut on the bias and left with a raw edge along the hem. The hooded cape is a variant of the *capuchin,* or monk's habit. It is gathered in a circular shape at the back to stand high without crushing the mobcap or coiffure underneath. The vestee is a practical solution for keeping the upper torso warm while leaving the hands free. By the late eighteenth century cardinals could be bought ready-made in England; thus, it is possible that this cape was imported rather than made in the colonies.

Afternoon Dress (robe à la française)
Cream-colored silk taffeta with figured stripes in cream-colored, blue, and yellow silks and silver-metallic threads, brocaded in rose, green, and brown silks and rose and silver metallic threads with scattered floral bouquets, trimmed with self-fabric ruching and polychrome fly fringe
French (?), about 1770–77
The Metropolitan Museum of Art
Purchase, Irene Lewisohn Bequest, 1959
CI 59.43.lab

Walking Dress (robe à la polonaise)
Golden-yellow China silk handpainted in an overall pattern of pink floral sprays and white butterflies, trimmed with self-fabric ruching
American, about 1778
The Metropolitan Museum of Art
Gift of the Heirs of Emily Kearny Rodgers Cowenhoven, 1970
1970.87ab
Illustrated, page 12

Eighteenth-century American colonial women of means were very interested in fashion. They generally followed the styles worn in England, but by the time of the American Revolution the French styles of Marie Antoinette were also influencing American taste. This *robe à la polonaise* attests to the fashion-consciousness of colonial women. It is made from a fine golden-yellow silk handpainted in China in a pattern of carnations and butterflies. Merchant seamen of New England traded extensively with the Orient, bringing back

Opposite: Figure 13. Light blue ribbed silk brocaded with polychrome silks and gold and silver in floral and foliate motifs. Detail of an evening gown (*robe à la française*). French, about 1758. The Metropolitan Museum of Art. Purchase, Irene Lewisohn Bequest, 1962. CI 62.28ab

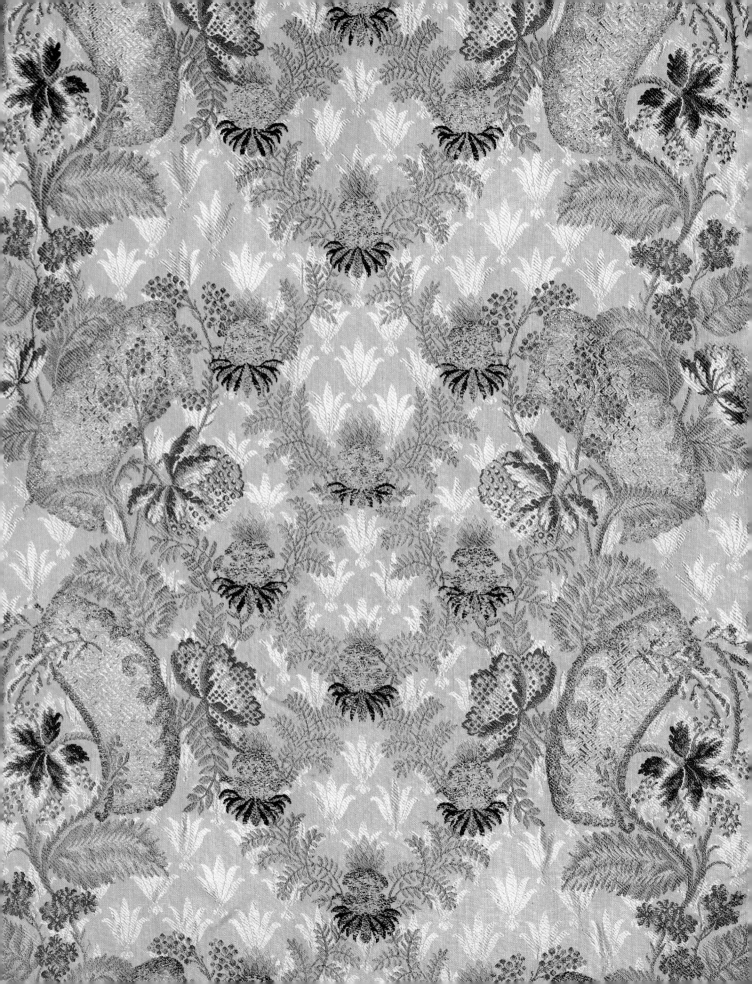

silks and gauzes for sale in England and in the colonies. The English, however, had to pay a tax on imported fabrics from which the American colonists were exempt, thus making the same elegant materials less expensive on this side of the ocean. Abigail Adams confirms this in a letter she wrote from London to a friend in Boston: "As to India handerkerchiefs, I give two guineas a-piece for them so they, as well as all other Indian goods are lower with you." The history of this dress implies that it was worn by Mrs. Jonathan Belcher, whose husband was the colonial governor of Massachusetts and New Hampshire from 1730 to 1741 and governor of New Jersey from 1746 until his death in 1757. However, the *robe à la polonaise* did not come into style during the lifetime of the first Mrs. Belcher, and if the second Mrs. Belcher, Mary Louisa Emilia Teal, did wear this dress, she would have been at least fifty years old at the time. It seems more likely that the dress was worn by a younger member of the family.

Jacket and Petticoat (caraco à la dévote)
Ivory-colored glazed silk striped in salmon, lime-green, yellow, and black, trimmed with self-fabric ruching; matching plain skirt
French, about 1778
Lent by The Brooklyn Museum
SL 81.74.lab

A lady of leisure would wear a peignoir at home in the morning. However, if she had activities outside early in the day, a simple *caraco* and matching skirt would suffice. The *polonaise*-style dress was also worn for daywear, replacing the *robe à la française* by the late 1770s. A *caraco* with *sabot* sleeves (flat elbow cuffs) worn opened wide over the skirt was called *à la polonaise* as well. A *caraco* that closed in the front, showing very little décolletage, was considered "pious," or *à la dévote*, like this example.

Day Dress (robe à la française)
Pale blue iridescent silk striped in pink, green, violet, dark blue, and ivory, trimmed with box-pleated self-fabric
French, about 1778
The Metropolitan Museum of Art
Purchase, Irene Lewisohn Bequest, 1960
CI 60.39.2ab

Day Dress (robe à l'anglaise)
Ivory-colored silk taffeta with matching satin stripes woven with red and green rosebuds
English, about 1778
The Metropolitan Museum of Art
Purchase, Hoechst Fibers Industries Gift, 1981
1981.313.2

Day Dress (robe à la polonaise)
Ivory-colored silk striped in dusty pink and brown, brocaded in polychrome silks in a floral and bird design, trimmed with rosettes of coral and white satin ribbon, edged with white lace
Italian, about 1778
Lent by the Tirelli Collection, Rome
SL 81.89.6ab

Formal Dress (robe à la française)
Gold twill and cream-colored satin stripes with an alternating rose and foliate pattern, trimmed with self-fabric ruching and multicolored fly fringe
English, about 1778
The Metropolitan Museum of Art
Purchase, Irene Lewisohn Bequest, 1961
CI 61.33.lab

Formal Dress (robe à la française)
White silk taffeta with woven green stripes and handpainted green floral sprigs, trimmed with self-fabric ruching
French, about 1778
The Metropolitan Museum of Art
Purchase, Irene Lewisohn Bequest, 1954
CI 54.70ab

Afternoon Dress (robe à l'anglaise)
Red Spitalfields satin brocaded in polychrome silks with scattered floral sprays, trimmed with self-fabric and polychrome fly fringe; matching stomacher
American, about 1778–80
Lent by Mr. and Mrs. F. Norman Christopher
SL 81.75ab

Bridal Gown (robe à l'anglaise)
Black silk with a *brocatelle* floral pattern, self-fabric ruching edged with matching braid, trimmed with white and blue striped silk bows and a gold medallion with a painted miniature; matching stomacher and petticoat
Swedish, about 1780
Lent by the Nordiska Museum, Stockholm
SL 81.91.la–f

Sophia Louisa Brück wore this black silk wedding dress to marry Christian Dybeck in 1780. The color and trimmings were dictated by the social position of the bridal

couple, in this case, middle class: Mr. Dybeck was the director of a sugar refinery. It is interesting to note that a woman of the middle class would choose to be married in the national costume rather than in an equally expensive dress that followed the French fashion. This is the only known surviving example of a woman's dress in the Gustavus III national Swedish style.

Day Dress (robe à l'anglaise)
Dark brown glazed chintz printed with a multicolored floral design
English, about 1780
The Metropolitan Museum of Art
Purchase, Irene Lewisohn Bequest, 1974
1974.195.2

Large eighteenth-century rooms with their high ceilings could be very cold in the winter, even when a fire was blazing on the hearth. English ladies wore quilted petticoats to fight the chill and continued the fashion out of doors during the cool days of spring. These petticoats, sewn in brightly colored silks and satins, were elaborately quilted all over in fanciful patterns, not just in front, where the overdress was drawn away. This glazed chintz day dress is a rare surviving example of the elaborate floral chintzes loved by the English in the second and third quarters of the century.

Robe and Petticoat (robe à l'anglaise)
White linen with *broderie anglaise* in a floral and foliate design
English, about 1780
Lent by Cora Ginsburg, Tarrytown, New York
SL 81.68.1ab

Unlike the privileged classes in France, the English aristocracy and gentry spent a great deal of time on their country estates. While there, ladies would wear simple gowns of linen or cotton for morning attire. This simple day dress with its white embroidery is the quintessential English country dress and is the very type of English fashion that later became the vogue on the Continent.

Day Dress (robe à l'anglaise)
Green striped silk taffeta with red *chiné* bands, trimmed with self-fabric ruching
English, about 1780
The Metropolitan Museum of Art
Purchase, funds from various donors, 1981
1981.245.2

Walking Dress (robe à la polonaise)
White China silk handpainted in an allover
 design of floral sprays in blue, lavender,
 red, and green
French, about 1780
The Metropolitan Museum of Art
Purchase, Mr. and Mrs. Alan S. Davis
 Gift, 1976
1976.146ab
Detail illustrated, page10

Lace Cape (capuchin)
Black blonde lace with a pattern of
 scattered flowers and leaves, ruffled
 border
English, about 1780
Lent by Martin Kamer, Switzerland
SL 81.111.6

Jacket and Skirt (pierrot and petticoat)
Ivory-colored glazed linen painted with a
 red and blue floral, grapevine, and
 butterfly design, trimmed with
 polychrome silk fringe and buttons
French, about 1784
Lent by the Union Française des Arts du
 Costume, Paris
SL 81.85.2ab

**Day Dress for a Quaker Lady (robe à
l'anglaise)**
Pale gray satin piped with white silk
American, about 1785
Lent by the Philadelphia Museum of Art
SL 81.80.1

The Quakers of the colonial period in
America were a prosperous people who
believed in nonviolence and advocated
simplicity in all things. Quakers looked
different from their neighbors because their
clothes, though cut in the English style,
were black, gray, or white and completely
unadorned with trimmings or lace. For
their best clothes, worn on Sundays, the
Quakers bought the finest fabrics they
could find in this limited palette. This
Quaker dress is made of gray satin
imported from China. The effect of the
costume, with its rich fabric and simple,
clean-cut lines, is one of elegant simplicity
worthy of a great *couturière*. The dress is
said to have been worn by Martha Hughes
when she was about seventeen years of age.
She died young in 1796, willing her
estate — including her mansion, Green Hill,
in Merion, Pennsylvania — to a cousin,
Mary Hollingsworth, whose descendants
presented this costume to the Philadelphia
Museum.

Afternoon Dress (robe à la polonaise)
Dark green ribbed silk brocaded in
 polychrome floral sprays, trimmed with
 self-fabric ruching edged with
 multicolored fly fringe
French, about 1785 (fabric about 1740)
The Metropolitan Museum of Art, New
 York
Dodge Fund, 1934
34.112a–c.

The term *robe à la polonaise* is often
applied to any late-eighteenth-century dress
with back drapery, but it should be
reserved for a dress with a fitted *anglaise*
back and a skirt that can be drawn up on
interior tapes into swags. These light,
informal dresses enjoyed great popularity
for daywear in the late 1770s and 1780s.
"Polish" fashions had appeared earlier in
honor of Queen Maria Leczinska, who was
a Polish princess before she married Louis
XV. The "Polish" styles consisted mainly of
gowns trimmed with fur or a brocaded fur
pattern. Camisoles, *caracos*, bonnets, and
even men's frock coats were also called *à la
polonaise* at the height of the fashion in
1780.

Afternoon Dress (robe à l'anglaise)
Pink taffeta woven in a *chiné à la branche*
 pattern in shades of red, green, and
 purple, trimmed with self-fabric ruching
French, about 1785
Lent by the National Museum of American
 History, Smithsonian Institution,
 Washington, D.C.
SL 81.92.lab

Afternoon Dress (robe à la polonaise)
Green and white striped satin imberline
 (silk and linen), trimmed with pleated
 self-fabric and green silk binding
French, about 1785
The Metropolitan Museum of Art
Purchase, Irene Lewisohn Bequest, 1965
CI 65.13.2a–c

Afternoon Dress (robe à l'anglaise)
Lavender and white striped silk taffeta
 trimmed with self-fabric ruching
French, about 1785
The Metropolitan Museum of Art
Purchase, Irene Lewisohn Bequest, 1966
CI 66.39ab

Bodice (caraco)
Blue and gold silk damask with gold silk
 buttons, trimmed with blue silk ribbon
 and self-fabric buttons
Italian (?), about 1785
The Metropolitan Museum of Art
Purchase, Catherine Breyer Von Bomel
 Foundation Gift, 1981
1981.210.7

Afternoon Dress (robe à la polonaise)
White satin figured in a green lattice design
 with a green and brown ribbon-stripe
English, about 1786
The Metropolitan Museum of Art
Purchase, Irene Lewisohn Bequest, 1975
1975.274.la

Walking Dress (robe à la polonaise)
Pale green and white silk taffeta with an
 alternately striped pattern of white with
 red flowers and imitation sequins
French, about 1786
The Metropolitan Museum of Art
Purchase, Irene Lewisohn Bequest, 1968
CI 68.57

**Walking Dress (robe à la polonaise aux
ailes)**
Rose-colored moiré striped in pale green
 and white satin, overlaid with serpentine
 stripes in a carnation and ribbon motif,
 and trimmed with puckered pale green
 and pink silk and matching braid
French, about 1787
The Metropolitan Museum of Art
Purchase, Irene Lewisohn Bequest, 1960
CI 60.40.3

Most surviving eighteenth-century costumes
have been altered several times. Ladies
updated their dresses, then passed them on
to relatives or servants, who made further
changes to adjust the size. There was also a
thriving second-hand clothes market. This
winged *polonaise* is so small that it must
have been worn by a girl of no more than
fourteen. The dress's small size and the

radical fashion change in the last decade of the eighteenth century helped to preserve it from alterations or subsequent wear for fancy dress.

Redingote
Pale green figured silk trimmed with pink and white ribbon appliqués in a bowknot border, rose-colored and silver sequins, and floral embroideries in pink and green silks, edged with pleated gauze
Italian, about 1788
Lent by the Tirelli Collection, Rome
SL 81.89.5ab

Italian ladies followed French fashions in the eighteenth century, but had their clothes made in fabrics and colors more suited to their climate, as is apparent in this Venetian redingote, with its light trimmings and bright green figured silk. The dressmaker or tailor borrowed the basic silhouette, with its tight sleeves and revers collar, from French models, but fitted the back in an unusual manner, using small fan pleats, and gave the costume a matching skirt. The last two features are not generally found in similar French costumes. The lady who wore this dress was a member of the family of the counts of Polesini.

Two-piece Dress (caraco and petticoat)
White muslin embroidered with a grapevine motif in purple and green
French, about 1789
Lent by the Musée de la Mode et du Costume, Paris
SL 81.83.4ab

Afternoon Dress
Ivory-colored striped taffeta brocaded with polychrome silks in floral sprays, trimmed with self-fabric ruching
German, about 1792
The Metropolitan Museum of Art
Gift of Mrs. Herbert Schwarz, 1945
CI 45.6ab

Day Dress
Dark green cotton *toile de Jouy* printed with scattered flowers in red, gold, and blue; self-fabric trim
French, about 1793
The Metropolitan Museum of Art
Purchase, Irene Lewisohn Bequest, 1960
CI 60.26.3ab

With the opening of the Eastern markets, Indian printed cottons found their way into France. At first they were very expensive, and French manufacturers tried to copy them by printing designs with wooden blocks on cotton. The silk and wool industries objected, and numerous edicts

forbidding the importation or manufacture of printed textiles were issued. The edicts were universally ignored, and by 1759 all restrictions had been removed. Factories for the production of printed cottons opened in Nantes, Rouen, and Lyons, but the most famous center was at Jouy. Its founder, Christophe-Philippe Oberkampf, developed a system of fast-color dyeing and invented the copperplate printing process. The engraver Jean-Baptiste Huet, the principal designer for the Jouy factory between 1783 and 1811, probably designed the pattern on this *toile de Jouy* day dress, which has been identified as *les bonnes herbes*.

Round Gown
Dark green and purple striped taffeta brocaded at the hem with white daisy-and-ribbon garlands
Italian, about 1795
The Metropolitan Museum of Art
Purchase, Irene Lewisohn Bequest, 1979
1979.20

Few true examples of the transitional fashions of the 1790s survive. This round gown displays both the fullness of the skirts of the 1780s and the high bosom and waistline of the Consulate period. Even the woven border at the hem recalls the floral and ribbon motifs found in brocades and embroideries from the 1760s on, rather than later classical designs. This day dress was worn by a Neapolitan lady, but its style is very much in the relaxed English taste, which stressed mobility and simplicity in choice of fabric and decoration.

Round Gown
Red silk brocaded in a silver floral pattern
French, 1795 (fabric about 1735)
The Metropolitan Museum of Art
Purchase, Irene Lewisohn Bequest, 1964
CI 64.32.2

Round Gown
White checkered mull printed with an allover floral pattern in black, red, and green, trimmed with self-fabric
English, about 1796
The Metropolitan Museum of Art
Gift of Alfred Lunt, 1955
CL 55.50.4

Redingote
Yellow and white striped satin with puffed white gauze sleeves trimmed with off-white braid
English, about 1798
The Metropolitan Museum of Art
Gift of Irene Lewisohn, 1937
CI 37.46.1

The redingote derived from ladies' riding coats, with their close-fitting bodices and overskirts worn closed in the front or cut away to reveal the lighter-colored petticoats. The stylishness and comfort of this costume made it popular for daywear. By the end of the 1790s ladies' waists had "ascended to the shoulders" and only the sleeves, which stopped at the elbow and were heavily trimmed or puffed out, had concentrated ornamentation.

Day Dress (round gown)
White linen printed in blue with a scattered floral design
American, about 1798 (fabric earlier)
Lent by the Fairfield Historical Society, Fairfield, Connecticut
SL 81.79

Round Gown
Olive-green silk taffeta pin-striped in yellow with a horizontal shadow-stripe in teal blue
American, about 1798
The Metropolitan Museum of Art
Gift of Ted Reynolds, 1958
CI 58.60

Round Gown
White mull embroidered with white cotton in a foliate pattern
English, about 1798
The Metropolitan Museum of Art
Purchase, German Fur Federation Gift, 1981
1981.315.3

Day Dress (round gown)
Ivory-colored silk taffeta embroidered with pink and green silk roses and black silk and silver sequin stars
Viennese, about 1798
The Metropolitan Museum of Art
Gift of Lee Simonson, 1939
39.13.106

MEN'S COSTUMES

Jousting Costume

Red wool couched with gold metallic
thread in a floral and foliate pattern,
trimmed with matching buttons and a
star of the order of the elephant, with
cuffs and lining of cream-colored satin
brocaded in red silks and gold metallic
thread in a sun, floral, and vine design;
matching swordbelt
Danish, about 1690
Lent by the Rosenborg Palace, Copenhagen
SL 81.81.lab

The medieval tradition of jousting, in which
participants riding richly caparisoned
horses and armed with blunted lances
performed feats of skill, was revived for the
court masques and carousels of the young
Louis XIV. The Scandinavian courts, under
French influence, put on elaborate jousts to
celebrate the king's birthday or other
important state occasions. King Christian V
of Denmark wore this superb red wool
costume for a court joust between 1685 and
1695. The costumes worn for these festivals
were very theatrical in design, but were
made of the finest materials and
embroideries. They also show the growing
European interest in Orientalism, as the

participants were dressed as Chinese,
Turkish, Indian, or Russian knights
complete with turbans, plumes, and other
exotic touches.

Man's Wedding Suit

Crimson silk velvet couched in silver
metallic threads in a foliate, *rocaille*,
and peacock-feather design, trimmed
with matching buttons and a star of the
order of the elephant; matching
breeches with swordbelt; waistcoat of
lace-pattern brocade in light blue silk
and silver metallic thread in a floral and
foliate pattern
Danish, about 1695
Lent by the Rosenborg Palace, Copenhagen
SL 81.81.2a-c

This superb costume was probably worn by
King Frederick IV of Denmark in 1695,
when, as crown prince, he married Princess
Louise of Mecklenburg. It is one of the
finest surviving men's court suits from the
period. The quality of the silver embroidery
indicates a French origin or a French
master embroiderer working in
Copenhagen. The "lace-pattern" blue
damask used for the waistcoat was most
likely woven in Lyons. It is interesting to
note that the tailoring of the coat is not of
the standard of the material. The tailor
awkwardly pieced the velvet across the
shoulder blades, which, fortunately for him,
were covered by the long, curled wig then
in fashion.

Buff Coat

Tan leather
German, end of 17th century
The Metropolitan Museum of Art
Gift of William H. Riggs, 1913
25.135.87

Venetian Footman's Costume for a Masked Ball

Cloth of silver trimmed with rust-colored
velvet and gold metallic braid, fringe,
and buttons; matching fringed breeches;
waistcoat of cloth of gold trimmed with
silver metallic braid, fringe, and buttons;
hat of rust-colored velvet and cloth of
silver trimmed with black velvet, silver
and gold metallic braid with a gold
passementerie topknot
Danish, 1710
Lent by the Rosenborg Palace, Copenhagen
SL 81.81.3a-d

Masquerade balls were very popular in the
eighteenth century, both at the royal courts
and in the homes of the aristocracy.
Royalty and their courtiers enjoyed
dressing up in exotic styles and wearing
fanciful masks, which assured a certain
degree of anonymity and undoubtedly

released inhibitions. Princes burdened with
a tiresome court etiquette liked to believe
that they were unrecognized and free for
an evening. Louis XV even took the
precaution of having eight identical
costumes made for himself and his
gentlemen. They were dressed as clipped
yew trees and gave their name to the
famous 1745 ball at which Louis XV met
his future mistress, Madame de
Pompadour. This sumptuous footman's
costume was worn by Frederick IV of
Denmark for a Venetian masquerade held
in Copenhagen in 1710. It is cut like a
servant's costume, down to the cap with
stiffened brim (*cappello di palafreniere*),
but the fabrics and trimmings are worthy of
a prince.

Waistcoat

Cloth of silver brocaded in a white floral
vine pattern and embroidered in gold
thread with a lily design, trimmed with
gold-tinsel buttonholes and buttons, with
sleeves and back of white floral brocade
Italian, about 1725
Lent by the Tirelli Collection, Rome
SL 81.89.4

Man's Dressing Gown (robe de chambre)

Ivory-colored silk faille brocaded in green,
blue, and pink silks in a foliate and lace
pattern, lined in yellow taffeta; matching
waistcoat
French, about 1730
The Metropolitan Museum of Art
Gift of Chester Dale, 1953
CI 53.74.7ab

Man's Suit

Taupe-colored cut and uncut velvet in a
floral pattern, with metal buttons,
trimmed with tinsel and yellow thread,
and cuffs and pocket flaps lined in red
silk twill; matching waistcoat lined in
blue plush with long sleeves
English, 1730–40
The Metropolitan Museum of Art
Purchase, Irene Lewisohn Bequest, 1977
1977.309.lab

Men's coats were cut without a seam at the
waist throughout the eighteenth century. In
the first half of the century they had broad
skirts with three vents reaching to the hips,
one at the center back and two on the
sides. These vents were usually pleated
several times and were occasionally
stiffened with wicker or even whalebone.
According to Read's *Weekly Journal* of
1736, "the pleats of the coat were made to
stick out very much in imitation of the
ladies' hoops." This taupe-colored suit is a
fine example of the fashion.

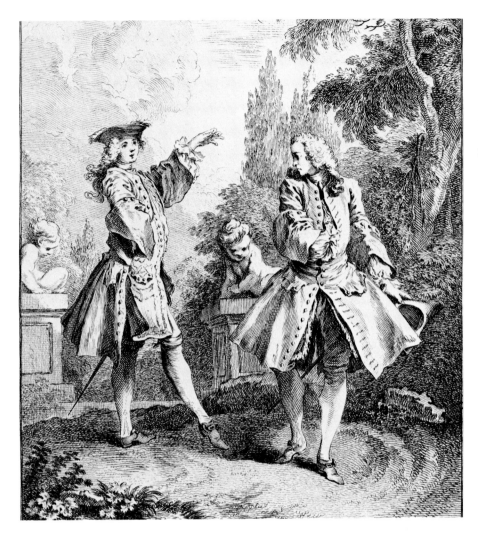

Man's Dressing Gown (banyan)
Brown figured silk faille in a geometric
 pattern
English, about 1735–40
The Metropolitan Museum of Art
Purchase, Irene Lewisohn Bequest, 1981
1981.208.2

Man's Three-Piece Suit
Blue uncut velvet, voided and patterned in
 an allover horizontal zigzag pattern
 interspersed with formal leaf-and-bud
 motifs, trimmed with gold braid and
 large gold metal buttons
French, 1740s
The Metropolitan Museum of Art
Purchase, Irene Lewisohn Bequest, 1962
CI 62.27a–c

Gentlemen all over Europe wore three-
piece velvet suits, similar to this one, to
show that they were men of substance. The
suits of the middle classes and of the
aristocracy were strikingly different in the
quality of the materials used and in the
standards of workmanship. A Mr.
Campbell, writing in *The London Tradesman*

in 1747, listed the requirements for a first-
rate tailor:

> He ought to have a quick Eye to steal
> the Cut of a Sleeve, the Pattern of a
> Flap, or the Shape of a good Trimming
> at a Glance; any Bungler may cut out a
> Shape when he has a Pattern before
> him, but a good Workman takes it by
> his eye in the passing of a
> Chariot.... He must be able, not only to
> cut for the Handsome and Well-shaped,
> but to bestow a good shape where
> Nature has not designed it.... His hand
> and his head must go together. He must
> be a nice Cutter and finish his work
> with Elegancy.... They make a
> handsome Penny and would raise
> Estates thereon were it not for the
> Delays in Payment among the Quality.

Although splendidly dressed, the
aristocracy paid little heed to their tailors'
bills, often dragging their credit on for
years at a time.

Cardinal's Soutane
Purple moiré silk trimmed with red silk
 cuffs and red buttons
Italian, about 1740
Lent by the Tirelli Collection, Rome
SL 81.89.2a

This cardinal's soutane was worn by a
member of the princely Roman family of
Giustiniani-Bandini. It is made in bishop's
purple moiré, but the cuffs and fifty-three
silk-covered buttons are in cardinal-red
silk. The small size of the costume would
seem to indicate that one of the younger
sons of the family — perhaps Cardinal Carlo
Sforza Giustiniani-Bandini — was given a
cardinal's hat at an early age.

Waistcoat
Cream-colored glazed cotton painted in
 gold metallic and shades of rose, blue,
 and purple in a floral and foliate
 pattern, trimmed with self-fabric buttons
French, mid-18th century
The Metropolitan Museum of Art
Rogers Fund, 1935
35.142

Man's Dressing Gown (banyan)
Ivory-colored linen printed in brown, blue,
 and red in an allover floral and
 vermicelli motif, trimmed with a tan and
 white cotton twisted cord belt with
 matching tassels
American, mid-18th century
The Metropolitan Museum of Art
Gift of Kate C. Lefferts, 1973
1973.195.1ab

Man's Hunting Vest
Beige doeskin embroidered with
 polychrome silks in a floral design,
 edged with red doeskin, laced at the
 sides and back with green silk ribbon
German, about 1750
The Metropolitan Museum of Art
Gift of Mrs. Robert Woods Bliss, 1943
43.90.12

Considering the formal code of etiquette
that governed eighteenth-century life, it is
not surprising that gentlemen did not
generally remove their jackets in public.
Tailors made men's waistcoats of the most
beautiful fabrics in front and used sturdy
linen or cotton, often of a very coarse
weave, to finish the back. Although formal
attitudes have changed, today men's vests
are still made with a contrasting and
usually less expensive fabric for the backs.
Sportsmen were allowed to play cricket or
to bowl in their shirt-sleeves. This
elaborately laced waistcoat embroidered on
both sides was certainly not intended to be
covered by a jacket. Perhaps it was a man's
undress wear for casual hunting or riding
on his estate.

Man's Three-Piece Suit
Rose-colored and blue *gros de Naples changeante* embroidered in a foliate and *rocaille* design in chain stitch in shades of blue; matching waistcoat and breeches
French, about 1755
Lent by the Musée de la Mode et du Costume, Paris
SL 81.83.8a–c

Man's Frock Coat
Maroon silk faille trimmed with matching Brandenburgs; once edged with white fur piping
English, about 1760
The Metropolitan Museum of Art
Purchase, Irene Lewisohn Bequest, 1975
1975.128.3

Uncut Waistcoat
Blue silk faille embroidered with silver sequins and thread in a floral and foliate design
European, about 1760
The Metropolitan Museum of Art
Purchase, German Fur Federation Gift, 1981
1981.14.6

The fashionable mercer sold men's waistcoats already embroidered on a length of material. A gentleman brought this material to his tailor's shop, where his measurements were taken and the waistcoat cut out and completed with a sturdy cotton or linen back. This method of assemblage lessened the time a man had to wait for a new waistcoat and also allowed easy shipping to other countries in Europe and to colonies abroad.

Man's Dressing Gown (robe de chambre)
Pink and gray striped silk faille brocaded with white, blue, and green silks in a latticed floral pattern, lined in natural linen printed with a brown scalloped pattern; matching attached vest
French, about 1760
The Metropolitan Museum of Art
Purchase, Irene Lewisohn and Alice L. Crowley Bequests, 1976
1976.149.1

Man's Three-Piece Suit
Sèvres-blue cut and uncut velvet on an ivory-colored silk ground in an allover floral pattern, trimmed with large gilded buttons; matching pants and waistcoat
French, 1765 (fabric earlier)
The Metropolitan Museum of Art
Purchase, Irene Lewisohn Bequest, 1964
CI 64.31.2a–c

Man's Hunting Suit
Blue wool trimmed with crimson velvet, gold and silver metallic braid, gold buttons in a basketweave pattern, and the star of the order of the elephant; waistcoat and breeches of red wool trimmed with gold buttons and braid; swordbelt of gold and silver metallic braid with a gold buckle; hat of black felt trimmed with gold metallic braid and a gold button; jackboots of black leather with metal spurs
French, about 1768
Lent by the Rosenborg Palace, Copenhagen
SL 8.81.4a–f

In 1768 Christian VII of Denmark made a grand tour of northern European courts, including that of his brother-in-law George III of Great Britain. The nineteen-year-old monarch was also received by Louis XV at Versailles with customary honors. The French king presented his "cousin" with this royal hunting uniform, required wear for all noblemen who had sufficient armorial quarterings to take part in the St. Hubert hunt. The breeches are lined in yellow chamois, which accounts for their tight fit. The rigid black boots that complete the uniform were traditional for hunt costumes throughout the century. They were practical as long as one was riding or standing, but if it was necessary to sit on the ground they could be awkward, as portrayed in Carle Van Loo's painting *Le Halte de la Chasse*, in the Louvre. Considering the small stature of the king, this costume must have overwhelmed him. No complete St. Hubert hunt costumes have survived in France, but there is another example, also presented by Louis XV, preserved in the Royal Armory, Stockholm.

Man's Three-Piece Suit
Striped pink, brown, and ivory-colored figured silk embroidered with polychrome silk threads in a floral spray design; self-fabric buttons; matching pants and waistcoat of cream-colored silk faille embroidered with polychrome silks in a pattern of floral sprays with a flower-garden border
French, about 1770
The Metropolitan Museum of Art
Fletcher Fund, 1961
CI 61.14.2a–c

Man's Formal Suit
Brown voided velvet on a beige ground in a geometric pattern embroidered with ivory-colored floss in a floral design with white net appliqués, trimmed with self-fabric buttons; matching breeches; waistcoat of silver figured silk embroidered in a multicolored foliate motif and floral border, trimmed with silver sequins
English (?), about 1770
The Metropolitan Museum of Art
Purchase, Irene Lewisohn Bequest, 1961
CI 61.35a–c

A gentleman's embroidered suit was a very expensive item of dress in the eighteenth century, principally because of the amount of skill and labor required to produce it. In France the guild of embroiderers carefully controlled the industry. Only a master embroiderer could make up the designs and designate the types of stitches to be used. Although women did most of the actual work, they were prevented by law from becoming masters in their field, a designation reserved for men only. Once a design was completed by the master, apprentices transferred it to the silk or velvet sheet that was already stretched on a large wooden frame. When this was laid flat, a number of embroiderers could work on a suit at the same time. An English lady visiting Lyons in 1784 left the following entry in her journal: "At the manufacture of all the very rich stuffs for furniture and for very fine embroidery. A very richly embroidered satin suit of clothes for men, about seventeen or eighteen Louis. We saw the pattern of one in velvet, with fake stones set in silver, like diamonds disposed upon it like embroidery, which they had made for Prince Potemkin, and had cost 1,000 Louis, it must have been frightfully heavy." Embroidery of garments reached its apogee in the last quarter of the eighteenth century. The industry was completely disrupted by the French Revolution, and the subsequent slackening of demand for embroidered garments delivered the final blow.

Man's Formal Suit
Beige cut voided velvet woven in a red and green rosebud pattern on a white ground, trimmed with paste buttons; matching waistcoat and breeches
French, about 1770
The Metropolitan Museum of Art
Rogers Fund, 1911
11.51.3a–c

Man's Frock Coat
Ivory-colored wool trimmed with silver
 braid and silver lamé buttons
English, about 1770–80
The Metropolitan Museum of Art
Purchase, Irene Lewisohn Bequest, 1981
1981.208.3

Man's Frock Coat
Aubergine-colored velvet embroidered with
 polychrome silks in a classical motif of
 floral *epergne* and garlands, trimmed
 with self-fabric buttons
French, about 1774
The Metropolitan Museum of Art
Rogers Fund, 1911
11.50.1

Venetian Servant's Livery
Red wool trimmed with polychrome cotton
 galloon, multicolored braided frogs, and
 buttons; waistcoat of blue satin with
 matching braid
Italian, last quarter of 18th century
The Metropolitan Museum of Art
Rogers Fund, 1925
26.56.10a–c

Man's Day Suit
Purple diagonally striped voided velvet on
 a ground pin-striped in pale green, gold,
 and ivory-colored silks, trimmed with
 self-fabric buttons; matching breeches
French, about 1775
The Metropolitan Museum of Art
Purchase, Irene Lewisohn Bequest, 1968
CI 68.68.1ab

Man's Court Coat
Deep purple cut velvet in a geometric
 pattern on a violet ground embroidered
 with polychrome silks in a floral design,
 with self-fabric buttons; waistcoat of
 white embroidered in purple and brown
 silks in a floral and foliate pattern
French, about 1775
The Metropolitan Museum of Art
Rogers Fund, 1932
32.35.13ab

Man's Summer Suit
Cyclamen-colored silk faille embroidered
 with polychrome silks, silver metallic
 thread, and silver sequins in a floral
 garland design, trimmed with self-fabric
 buttons; matching pants
French, about 1775–80
The Metropolitan Museum of Art
Gift of International Business Machines
 Corporation, 1960
CI 60.22.1ab

Man's Three-Piece Suit
Cyclamen-colored ribbed silk embroidered
 with polychrome silks in floral sprays
 and a *rocaille* lace pattern, trimmed
 with self-fabric buttons; matching pants;
 waistcoat of white satin embroidered
 with a multicolored floral-spray border
 with brown silk edging
English, about 1775–80
The Metropolitan Museum of Art
Purchase, Irene Lewisohn Bequest, 1960
CI 60.38a–c

Man's Three-Piece Suit
Chartreuse satin embroidered with white,
 pink, and beige silks in a foliate design,
 trimmed with self-fabric buttons;
 matching pants; waistcoat of white satin
 embroidered with polychrome silks in a
 scattered flower and floral-spray design
French, 1775–80
The Metropolitan Museum of Art
Gift of Mrs. Edwin L. Pabst, 1960
CI 60.50a–c

Man's Formal Coat
Black and gold voided velvet in a stylized
 peacock-feather pattern embroidered
 with polychrome silks in a floral design,
 trimmed with self-fabric buttons
French, 1775–80
The Metropolitan Museum of Art
Gift of Lilly Daché, 1968
68.45
Illustrated, page 14

Man's Three-Piece Suit
Rust-colored corduroy trimmed with tinsel-
 covered buttons and gold braid;
 attached wigbag (*crapaud*) of black silk
 faille trimmed with black satin ribbon
English, 1775–80
The Metropolitan Museum of Art
Purchase, Irene Lewisohn Bequest, 1977
1977.308.1

Man's Dressing Gown
Ivory-colored parchment silk brocaded with
 polychrome silks and gold metallic
 thread in a scattered floral and meander
 pattern; attached matching belt
Danish, about 1778
Lent by the Rosenborg Palace, Copenhagen
SL 81.81.5

Man's Three-Piece Suit
Dark brown velvet corduroy embroidered
 with white, light green, and yellow daisy
 sprays, trimmed with self-fabric buttons;
 matching pants; waistcoat of ivory-
 colored satin embroidered with a
 multicolored floral motif and daisy-spray
 border
French, about 1778
The Metropolitan Museum of Art
Rogers Fund, 1932
32.40a–c

Man's Court Costume
Black silk twill trimmed with salmon-pink
 buttons, cord, and satin trim; waistcoat
 of salmon-colored satin; black silk
 breeches with paste buckles; pink taffeta
 sash trimmed with matching braid and
 fringe; black taffeta cape edged with
 pink taffeta and matching braid
Swedish, about 1780
Lent by the Nordiska Museum, Stockholm
SL 81.91.2a–d

King Gustavus III of Sweden was a gifted
and enlightened monarch who encouraged
the development of the arts and literature
in his country in the 1770s and 1780s. He
was a talented playwright and displayed a
keen interest in the history of the
Scandinavian kingdoms. In 1778 Gustavus
III tried to break the dominance of French
fashions by devising a Swedish national
costume to be worn by all classes of
society. One's position in the social
structure dictated not only the style to be
worn, but also what fabrics could be used
and in what colors. For inspiration, the
king looked back to the styles worn in the
time of Gustavus II, under whose reign at
the beginning of the seventeenth century
Sweden became a great European power.
This "Swedish" costume was an eclectic
mixture of historical detailing,
contemporary fashion, and elements of
fancy dress. The gentleman's jacket was
simplified, with distinctive bands added at
the edge of the shoulders like a vestigial
slashed sleeve. An oversize sash and a
romantic cape completed the ensemble.
Swedish national dress for women was cut
like a fashionable dress, often a *robe à la
polonaise*, with the addition of puffed
sleeves occasionally slashed like a sixteenth-
century man's doublet, special bowknots of
ribbon, and a standing pleated ruff.
Although trying to abolish French
influences in fashion, Gustavus III was
influenced by the French fashion *à la
Henri IV* worn in the 1770s to honor Louis
XVI, who was called popularly "le nouveau
Henri IV." In late seventeenth-century
Denmark Christian V had tried to reform
court fashion and reintroduce the "Spanish"
styles worn in the days of his grandfather,
Christian IV. It is interesting to note that
all three of these national styles look back
to a period in their nations' histories when
they were ruled by absolute monarchs
unencumbered by modern political
problems. The Swedish national costume of
Gustavus III was required attire at the
royal court and had some following in the
middle class as a costume for important
occasions. Many genre paintings and
portraits of this period record this fashion,
which survived until the end of the
century.

Man's Frock Coat
Pale blue-green cut velvet with a black
 foliate pattern, voided stripes on a
 ground of yellow and rust-colored satin,
 trimmed with self-fabric buttons
French, about 1780
The Metropolitan Museum of Art
Purchase, Hoechst Fibers Industries Gift,
 1981
1981.313.1

Man's Summer Coat
Indigo-blue and white checked cotton with
 self-fabric buttons; unlined
American, about 1780
The Metropolitan Museum of Art
Gift of the New-York Historical Society,
 1979
1979.346.3

Costume of the Prosecutor of San Marco
Red silk damask in a large floral, foliate,
 and crown pattern; matching stole in cut
 velvet
Italian, about 1780
Lent by Count Maurizio Antonio
 Sammartini, Venice
SL 81.90.1ab

Paolo Renier of the Pisani-Moretti family
wore this costume in 1780–81 when he was
procuratore (prosecutor) of San Marco.
The outer robe (*robbone*) and the velvet
stole had been the official garments for this
governmental post since the sixteenth
century. The red brocade and velvet are
also in imitation of cinquecento fabrics,
though they were actually woven in the
eighteenth century. A full judge's wig
completed this costume, as seen in
Giovanni Battista Tiepolo's portrait of
Giovanni Querini, a predecessor of Renier
(Galleria Querini Stampalia, Venice). In
1782 Paolo Renier was elected doge of
Venice; he was the next-to-last Venetian
nobleman to hold that prestigious title.

Man's Dressing Gown (banyan)
Golden-yellow silk damask in a chinoiserie
 floral design with self-fabric buttons;
 matching attached waistcoat
English, about 1780
The Metropolitan Museum of Art
Purchase, Catherine Breyer Van Bomel
 Foundation Gift, 1978
1978.135.1

For at-home wear, a gentleman had a
dressing gown, often with a matching
waistcoat, and an undress cap or turban.
As for breeches, they were not designed
especially for this casual ensemble, but
rather borrowed from other suits. The
dressing gown was cut like a man's loose
coat and usually hung to the floor, though
there were also versions that stopped below

the knees. Since there were no fastenings,
the wearer overlapped the dressing gown in
front when he walked so that the sides did
not billow out behind him. The sleeves
were originally rolled back to form cuffs,
but later dressing gowns display the
fashionable cuff of their period. In England
these dressing gowns were called "banyans"
or "Indian nightgowns" because of their
kimono-like form and Eastern origin.
Banyans were made in a variety of fabrics,
including silk brocades, damasks, and
printed cottons. Winter banyans were
occasionally quilted for extra warmth.
Gentlemen received friends while attired in
banyans as a sign of their informality and
of their intimacy with the visitor. By the
1780s gentlemen ventured out of doors in
this comfortable and stylish costume.
According to *Town and Country Magazine*
in 1785: "Banyans are worn in every part of
the town from Wapping to Westminster,
and if a sword is occasionally put on it
sticks out of the middle of the slit behind.
This however is the fashion, the ton, and
what can a man do? He must wear a
banyan." This yellow damask banyan with
its bold Chinese Chippendale–inspired
pattern would have been an imposing sight
on the streets or in the drawing rooms of
London.

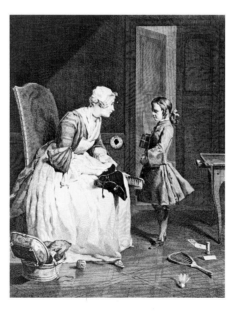

Uncut Waistcoat
Ivory-colored satin embroidered with
 polychrome silks and brown chenille in
 an allover leaf pattern and a floral and
 foliate border
English (?), about 1780
The Metropolitan Museum of Art
Purchase, Irene Lewisohn Bequest, 1966
CI 66.59.1ab

Uncut Waistcoat
Ivory-colored satin embroidered with
 polychrome silks, brown chenille,
 metallic thread, and metallic and
 mother-of-pearl sequins in an allover
 sprig-and-sunburst pattern and a border
 of floral sprays
French (?), about 1780
The Metropolitan Museum of Art
Purchase, Irene Lewisohn Bequest, 1966
CI 66.59.2ab

Uncut Waistcoat
Ivory satin embroidered with brown and
 blue silks, beige chenille, metallic
 thread, and silver sequins in an allover
 sprig design and a stylized leaf border
English (?), about 1780
The Metropolitan Museum of Art
Purchase, Irene Lewisohn Bequest, 1966
CI 66.59.3ab

Man's Summer Suit
Tan linen embroidered with pink silks in a
 floral, foliate, and *rocaille* pattern,
 trimmed with self-fabric buttons;
 matching pants and waistcoat
American, about 1780
Lent by Mr. and Mrs. Robert R. Atterbury
SL 81.70a–c

This rare linen suit shows that by the time
of the Revolution the wealthy colonial
American gentleman could be as
fashionably dressed as his European
counterparts. The subtle contrast between
the pink silk embroidery and the tan linen
is particularly successful. This suit was
worn by Elisha Boudinot of New Jersey
when he was a young man in his thirties.
Elisha was the younger brother of Elias
Boudinot, president of the Continental
Congress, and was himself commissioner of
prisoners for the state of New Jersey and
later a Supreme Court judge.

Man's Dressing Gown (robe de chambre)
Ivory-colored satin striped in yellow, rust,
 and shades of blue, with self-fabric
 buttons, lined in blue taffeta; matching
 vest
Italian, about 1780
The Metropolitan Museum of Art
Purchase, Irene Lewisohn Bequest, 1956
CI 56.5.1ab

Man's Cape
Brown camlet with a shoulder cape and
 chased metal hook closure
American, about 1782
Lent by the Philadelphia Museum of Art
SL 81.80.2

In bad weather or for traveling, a
gentleman wore a large cape. This garment
was usually made of a tightly woven wool
or camlet to keep the wearer warm and
relatively dry. This swashbuckling cape is
said to have been worn by Capt. Samuel
Morris, a wealthy landowner in
Pennsylvania.

Man's Formal Coat
Brown wool embroidered with white silks,
 gold metallic thread, and silver metal
 sequins in a foliate pattern, with
 matching buttons
French, about 1783
The Metropolitan Museum of Art
Gift of International Business Machines
 Corporation, 1960
CI 60.22.2a

Man's Suit (habit à la disposition)
Purple figured silk embroidered with
 polychrome silks and net appliqués in a
 floral and foliate pattern; embroidered in
 five sheets
French, about 1783
Lent by Martin Kamer, Switzerland
SL 81.111.7

Man's Day Suit
Pale blue and brown satin-striped ribbed
 silk trimmed with self-fabric buttons
French, about 1785
The Metropolitan Museum of Art
Gift of Mrs. Frank A. Zimino Jr., 1966
CI 66.1.2a

Man's Frock Coat
Dark brown wool embroidered in white,
 tan, and green silks and mother-of-pearl
 sequins in a palm-frond and floral-
 garland design; lighter brown wool
 sleeves
German (?), about 1786
The Metropolitan Museum of Art
Gift of Lee Simonson, 1939
CI 39.13.30

Man's Frock Coat
Green silk with woven purple stripes,
 trimmed with flower-shaped buttons of
 green and brown floss and silver
 metallic wire
French, about 1787
The Metropolitan Museum of Art
Gift of Alfred Lunt, 1959
CI 59.18.1

Man's Day Coat
White cotton with a small brown checkered
 pattern, trimmed with self-fabric
 buttons; unlined
American, about 1790
Lent by the Chicago Historical Society
SL 81.69.1

American gentlemen wore checked or
gingham cotton frock coats for casual wear
in the summer months. These coats were
not only stylish but were made of easily
cleaned and inexpensive materials. This is
an example of a European style adapted to
suit provincial needs.

Man's Frock Coat
Beige silk with beige satin stripes trimmed
 with buttons covered in gold and silver
 thread in a basketweave pattern
French (?), about 1792
The Metropolitan Museum of Art
Gift of Aline MacMahon, 1938
CI 38.90

Man's Riding Breeches
Tan buckskin with stirrups trimmed with
 metal and mother-of-pearl buttons
English, about 1795
The Metropolitan Museum of Art
Purchase, German Fur Federation Gift,
 1981
1981.12.2

Leather breeches were popular with sports-
minded English gentlemen for hunting and
riding. They were usually made in tan or
yellow leather with trouser legs long
enough to meet the tops of the boots.
Gentlemen bought their breeches from
special breeches-makers, who, because of
the nature of the material they worked in,
organized a separate business. The fashion
for English leather breeches spread to the
Continent during the anglomania of the
1770s and 1780s. European dandies
appreciated the tight fit of these breeches
while finding them supple enough to wear
while riding.

Man's Frock Coat
Olive-green and brown striped silk faille
 with a satin-stripe in yellow, rust, and
 blue, trimmed with buttons covered with
 matching silk threads
French, about 1795
The Metropolitan Museum of Art
Purchase, Irene Lewisohn Bequest, 1968
CI 68.68.2

Another English influence on European
fashions was the adoption of the *frac*, or
frock coat. It had a rolled collar, narrow
sleeves with small cuffs, and a short
waistline with cutaway tails. A late version,
like this example from the 1790s, was cut
almost to the middle of the chest to show a

good portion of the waistcoat when it was
buttoned; the *frac* was worn with
contrasting breeches. The fine muslin stock
worn with this jacket was wrapped around
the neck several times and tied in a large
knot under the chin.

Man's Highland Dress
Ribbed silk and wool mixture in Cameron
 of Erracht tartan pattern, trimmed with
 diamond-shaped silver buttons with
 thistle motif
Scottish, about 1796
The Metropolitan Museum of Art
Gift of Mrs. Alexander M. Welch, 1950
CI 50.97.2a–c

Venetian Servant's Livery
Mustard-yellow wool with red, white,
 yellow, and black cotton galloon,
 trimmed with matching tassels and
 buttons, with cuffs of dark blue wool;
 pale yellow wool waistcoat with brass
 buttons
Italian, 1st quarter of 19th century
The Metropolitan Museum of Art
Rogers Fund, 1925
26.56.8a–c

CHILDREN'S COSTUMES

Child's Dress
Pink satin embroidered with silver metallic
 thread in a floral and foliate pattern
 with pink and silver braid leading
 strings and matching stomacher
Swedish, about 1710
Lent by the Nordiska Museum, Stockholm
SL 81.91.4a–c

Boy's Jacket
Medium blue silk damask in rose and wing
 motifs, trimmed with matching buttons
 and faced with matching plush
English, mid-18th century
The Metropolitan Museum of Art
Purchase, Irene Lewisohn Bequest, 1975
1975.34.3

Young Girl's Dress
White cotton hand-quilted in an intricate
 allover design
Danish (?), 2nd half of 18th century
The Metropolitan Museum of Art
Gift of Lee Simonson, 1939
Gift of Mrs. DeWitt Clinton Cohen, 1940
CI 39.13.45; CI 40.126.1

Child's Dress (robe à la française)
Blue and white striped silk taffeta brocaded
 in polychrome silks in a floral spray and
 vine pattern, trimmed with self-fabric
 ruching and white lace
American, about 1770
The Metropolitan Museum of Art
Purchase, Irene Lewisohn Bequest, 1959
CI 59.43.1a–c

Young Girl's Riding Jacket
Cyclamen-colored camlet trimmed with
 matching buttons, Brandenburgs, and
 silk collar
Swedish, about 1780
Lent by the Nordiska Museum, Stockholm
SL 81.91.3

The young Swedish horsewoman who wore
this riding habit was following the rules of
national costume advocated by her king,
Gustavus III. Ladies' habits were generally
masculine in cut; this one is modeled on the
nobleman's court uniform and has long,
narrow sleeves with a vestigial slashed
sleeve at the shoulderline.

Boy's Suit
Pale blue figured silk with pink silk collar
 and cuffs couched with silver thread and
 blue tinsel in foliate motifs, trimmed
 with white, silver, and blue tinsel braid,
 tassels, and buttons; waistcoat of pink
 silk with matching trim
Italian, about 1790
Lent by the Tirelli Collection, Rome
SL 81.89.1ab

This costume is said to have been worn by
Prince Carlo Giustiniani-Bandini when he

was a little boy. Even as young children,
Italian princes were dressed for formal
occasions like miniature adults, in a style
that befitted their rank. Less formal
children's clothes, designed under the
influence of Rousseau's and Locke's
philosophies, were worn by aristocratic
children as daywear.

Young Girl's Day Dress (round gown)
White mull embroidered in chain stitch
 with burgundy, blue, and beige silks in
 a floral vine pattern
English (?), about 1798
The Metropolitan Museum of Art
Purchase, Irene Lewisohn Bequest, 1978
1978.280.2

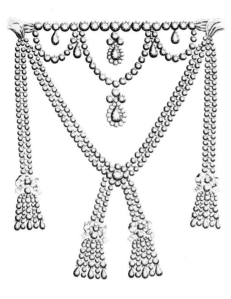

JEWELRY

Stomacher Brooch
Table-cut, lead foil diamonds set in silver in
 a floral and foliate design
English (?), early 18th century
Lent by a private collection, New York
SL 81.76.1

Brooch Pendant
Diamonds set in gold in a foliate and scroll
 pattern
Portuguese, early 18th century
The Metropolitan Museum of Art
Gift of Marguerite McBey, 1980
1980.343.9

Pair of Earrings
Jacinths set in gold in a stylized floral
 design with marquise-shaped pendants
Spanish, 18th century
The Metropolitan Museum of Art
Gift of Marguerite McBey, 1980
1980.343.32–33

Brooch
Diamonds set in silver in a bow-and-
 pendant design
Portuguese, 18th century
The Metropolitan Museum of Art
Gift of Marguerite McBey, 1980
1980.343.17
Illustrated, page 23

Pair of Earrings
Rubies and diamonds set in silver in a
 foliate design
Spanish (?), 18th century
The Metropolitan Museum of Art
Gift of Marguerite McBey, 1980
1980.343.6–7
Illustrated, page 23

Brooch Pendant
Diamonds set in gold in a bow- and
 pendant-cross design
Spanish (?), 1st half of 18th century
The Metropolitan Museum of Art
Gift of Marguerite McBey, 1980
1980.343.8a–c
Illustrated, opposite Contents page

Ring
Rose-cut diamonds set in gold and silver
English, mid-18th century
Lent by a private collection, New York
SL 81.72.1

Pair of Earrings (girandole earrings)
Pavé diamonds and rubies in a gold and
 silver setting
French, mid-18th century
Lent by Dona and Bernard C. Solomon
SL 81.87.4ab

Wrist Ornament
Chrysolites set in silver in a bowknot and
 foliate design
Dutch (?), mid-18th century
Lent by a private collection, New York
SL 81.76.7ab

Stomacher Brooch
Green paste stones set in silver in a floral
 and bow design
Spanish (?), mid-18th century
Lent by a private collection, New York
SL 81.76.3

Maltese Cross Pendant
Pavé diamonds in a silver setting
English, 2nd half of 18th century
Lent by Dona and Bernard C. Solomon
SL 81.87.7

Hair Ornament
Three chinoiserie figures under a parasol in
 diamonds, rubies, sapphires, emeralds,
 and citrines set in gold and silver;
 movable heads enameled in flesh tones
 on gold
German (?), about 1750
Lent by A La Vieille Russie, New York
SL 81.77

Hair Locket
Escutcheon-shaped crystal with a crown
 surrounded by almondine garnets set in
 gold
English, about 1750
Lent by Timothy John
SL 81.71.9

Pin and Pair of Earrings
Bowknot of emeralds and pearls set in
 gold; matching drop bowknot earrings
English, about 1750
Lent by Timothy John
SL 81.71.6a–c

Tiara
Diamonds set in silver and gold in a
 cornflower pattern
English, about 1750
Lent by Dona and Bernard C. Solomon
SL 81.87.1ab

Parure
Garnets or spinels set in gold; necklace in a
 floral and ribbon design with a pendant
 cross; pair of earrings with teardrop
 pendants; aigrette in a floral-spray and
 bowknot design with suspended
 pendants; hair ornament in a movable
 fan shape with a crescent at the base
European, about 1760
Lent by a private collection, New York
SL 81.76.6a–i

Pair of Earrings (girandole earrings)
Pavé diamonds in a gold and silver setting
English, about 1760
Lent by Dona and Bernard C. Solomon
SL 81.87.2ab

Hair Locket
Teardrop-shaped crystal set in gold
 trimmed with seven rose diamonds
English, about 1760
Lent by Timothy John
SL 81.71.14

Pendant
Painted oval enamel of *amor* crowning a
 pair of turtledoves with a garland of
 roses set in a twisted gold frame with a
 bowknot loop
Signed *Bourgoin*
French, about 1765
Lent by a private collection, New York
SL 81.76.4

Hair Locket
Oval crystal surrounded by almondine
 garnets set in silver
English, 1765
Lent by Timothy John
SL 81.71.8

Pair of Drop Earrings
Almondine garnets set in gold
English, about 1765
Lent by Timothy John
SL 81.71.7ab

The Queen's Necklace (modern copy)
White sapphires cut *à l'ancienne* and
 pearls trimmed with light blue velvet
 ribbons
Original by Boehmer and Bassenge
French, about 1774
Lent by the Musée National du Château de
 Versailles
SL 81.82.3a–c

This necklace *en esclavage* was copied from
a contemporary drawing of the original,
which consisted of a collar and breastplate
of diamonds with two chains of diamonds
suspended on either side of the bodice. The
court jewelers had originally intended this
necklace for Madame du Barry, but Louis
XV died before it could be purchased. It
was in turn offered to Marie Antoinette,
but Louis XVI balked at the price —
1,500,000 livres. The jewelers were
becoming desperate, since they had bought
the stones on credit and the interest was
mounting rapidly. In 1784 a beautiful
adventuress with an important-sounding
name — the Comtesse de la Motte-Valois
— offered her services as an intermediary
with her "friend," the queen. The "countess"
was a charlatan of the first order and soon
found a culpable fool to swindle in Cardinal
de Rohan, grand almoner of France. This
gullible prince of the Church desperately
wanted to become a minister of state, but
felt his path was blocked by Marie
Antoinette's enmity. He agreed to make a
large down payment on the diamonds after
he had received a forged document signed
by the queen. On February 1, 1785, the
court jeweler Boehmer delivered the
diamonds to the cardinal, who turned them
over to the countess, who handed them to a
"messenger from the palace." The diamonds
were subsequently smuggled across the
channel and broken up for the stones in
London. When the scandal broke at court,
Louis XVI decided to make an example of
the participants and to proclaim his wife's
innocence. The cardinal was arrested in the
state apartments and taken to the Bastille
still wearing his ecclesiastical robes! The
Parliament of Paris, a political body, was
ordered to judge the participants. The trial
generated great interest, for the dupe and
the swindler were only an excuse to put the
whole government on trial. Madame la
Motte-Valois was branded on her shoulder
with a "V" for *voleuse* (thief) and
imprisoned. The cardinal was acquitted,
and Marie Antoinette was regarded as
guilty. Napoleon, when looking back at the

origins of the French Revolution,
recognized the importance of "the affair of
the diamond necklace" in weakening the
monarchy's credibility with the public.

Necklace
Garnets in a star and foliate design set in
 gold
English, last quarter of 18th century
Lent by Cora Ginsburg, Tarrytown, New
 York
SL 81.68.3

The Liberty Necklace
Thirteen large square-cut emeralds, thirteen
 small emeralds, and thirteen graduated
 pear-shaped emeralds (all paste),
 surrounded by diamonds with a
 diamond foliate motif; original gold and
 silver setting
Original design attributed to Falige
French, about 1775
Lent by Van Cleef and Arpels, Paris
SL 81.78

The "liberty necklace" has a colorful history
in legend, but one that is impossible to
document. In 1850 the necklace appeared
mysteriously at the municipal pawnshop of
Paris, Mont de Piété. It was supposedly
intact and arrived with a romantic story. A
Polish countess at the court of Louis XVI
was in love with one of her dashing
countrymen, Tadeusz Kosciusko, who in
1777 was fighting with the Marquis de
Lafayette for the liberty of the American
colonies. At a masked ball the countess
heard that Philadelphia had been captured
by the British. Driven by concern for her
lover's safety, she called on Benjamin
Franklin in the middle of the night at his
home in Passy. Franklin, always eloquent,
but especially so when a beautiful woman
was his audience, reassured the countess
that the reports were exaggerated. In
gratitude she took off the necklace she was
wearing and presented it to him, saying:
"Take it. There are thirteen square-cut
emeralds and thirteen pear-shaped
emeralds, one for each of the thirteen
colonies. I beg you to accept these jewels in
the name of liberty." Franklin is said to
have given the necklace to his French
bankers, and all trace of it was lost during
the French Revolution. The necklace was
acquired by Van Cleef and Arpels in the
1920s, and they filled in the emeralds with
fine paste.

Memorial Ring
Putto and urn with the initials *MK*
 painted on ivory, surrounded by a row
 of rubies and a row of seed pearls set in
 gold
English, about 1775
Lent by Timothy John
SL 81.71.22

Man's Silhouette Ring
Silhouette of a lady with high-piled
 hairstyle in black on white enamel under
 crystal set in gold
French, about 1778
Lent by Timothy John
SL 81.71.19

Square Ring
Silver and rose-cut diamonds in a design of
 a pansy (*pensée*) plus *A Moi* ("think of
 me"), set on a cobalt-blue glass
 background in a gold mount
French, about 1780
Lent by a private collection, New York
SL 81.76.5

Ring
Amethyst-colored glass inlaid with rose
 diamonds and silver in a scroll pattern
 set in gold
French, about 1780
Lent by a private collection, New York
SL 81.72.2

Miniature Portrait Pendant
Portrait of a lady with a large plumed hat
 painted on ivory, set in gold
Signed *SCM*
French, about 1780
Lent by Timothy John
SL 81.71.17

Chatelaine with Watch
Gold with blue enamel set with pearls and
 diamonds
French, about 1780
Lent by Dona and Bernard C. Solomon
SL 81.87.3ab

Watch
Gold with colored-enamel cartouches
 trimmed with diamonds and a painted
 scene of a vestal virgin tending an altar
French, about 1785
Lent by Dona and Bernard C. Solomon
SL 81.87.8

Pair of Earrings
Country landscapes in polychrome feathers,
 surrounded by pearls in a gold setting
Italian (?), about 1785
Lent by Timothy John
SL 81.71.23ab

Pair of Pendant Earrings
Striped agate set in gold
English (?), about 1785
Lent by Timothy John
SL 81.71.1ab

Ring
Marquise-shaped carnelian surrounded by
 pearls set in gold, engraved inside *AMK*
English, about 1785
Lent by Timothy John
SL 81.71.21

Swivel Ring
Miniature silhouette of a woman
 surrounded by blue and green painted
 flowers on ivory; reverse with plaited
 blonde hair; monogram of seed pearls,
 set in bright-cut gold
English, about 1787
Lent by Timothy John
SL 81.71.20

Pair of Earrings
Carved mother-of-pearl set with seed
 pearls, central silver mount set with tiny
 rose diamonds; gold loops
English (?), about 1790
Lent by Timothy John
SL 81.71.2ab

Pair of Earrings
Citrines surrounded by seed pearls set in
 gold
English, about 1790
Lent by Timothy John
SL 81.71.4ab

Brooch
Gold and crystal case with wooden
 neoclassical "cameo" carving of a bearded
 man
English, about 1790
Lent by Timothy John
SL 81.71.12

Hair Locket
Crystal case surrounded by graduated
 pearls set in gold
English, about 1790
Lent by Timothy John
SL 81.71.15

Hair Locket
Crystal case surrounded by blue enamel
 and graduated pearls set in gold;
 inscribed on back *Grannie*
English, about 1790
Lent by Timothy John
SL 81.71.16

Pair of Earrings
Small gold hoops
French, about 1793
Lent by Timothy John
SL 81.71.23ab

Brooch
Seed pearls mounted on mother-of-pearl
 and gold wire in a design of a basket of
 flowers and leaves
English, about 1795
Lent by Timothy John
SL 81.71.13

Hair Brooch
Octagonal gold and crystal case with
 plaited blonde hair and monogram *MT*
English, about 1795
Lent by Timothy John
SL 81.71.11

Pair of Earrings
Oval garnets surrounded by seed pearls set
 in gold
English, about 1795
Lent by Timothy John
SL 81.71.3ab

Miniature Harp
Gold and colored enamel
Swiss, late 18th century (?)
Lent by Dona and Bernard C. Solomon
SL 81.87.9

Pendant
Zircons set in gold in a bow and foliate
 design with a pendant dove of the Holy
 Spirit with ruby eyes and beak
French, late 18th century (?)
Lent by a private collection, New York
SL 81.76.2

Brooch
Diamonds set in silver
French or Spanish, late 18th century
Lent by the Cooper-Hewitt Museum, New
 York
SL 81.113.1

ACCESSORIES

Hats

Circular "Flat" Hat
Leghorn straw with silver metallic thread,
 trimmed with narrow metallic lace; low
 crown
English, early 18th century
The Metropolitan Museum of Art
Purchase, Irene Lewisohn Bequest, 1969
CI 69.15.1

Man's Undress Cap
Ivory-colored linen embroidered with
 polychrome silks in a foliate, *rocaille*,
 and animal design, trimmed with a
 painted ivory button
French or Italian, early 18th century
The Metropolitan Museum of Art
Rogers Fund, 1926
26.231.9

Man's Dressing Cap
Pale blue silk embroidered with
 polychrome silks and silver metallic
 thread in a floral and *rocaille* pattern,
 banded in silk ribbon
Swiss, 1st quarter of 18th century
The Metropolitan Museum of Art
Purchase, Irene Lewisohn Bequest, 1980
1980.444.4

Man's Undress Cap
Ivory-colored linen with green, yellow, and
 red silk embroidery of a gentleman and
 lady seated in a landscape with palm
 trees and sheep, trimmed with a
 matching topknot
English, about 1705
The Metropolitan Museum of Art
Rogers Fund, 1939
39.145

For informal occasions at home a
gentleman discarded his curled wig for the
ease and comfort of a dressing cap. In
order to wear a heavy wig comfortably, a
man had to wear his own hair closely
cropped. Naturally, when the wig was off
he presented rather an awkward picture
and was exposed to cold drafts in chilly
rooms. Dressing caps were made in a wide
variety of materials, including silk, satin,
linen, and fur. The embroidery seen here —
probably the handiwork of a
gentlewoman — depicts on one side a
fashionably dressed man wearing an
undress cap while smoking, and on the
other side a lady in a formal dress in a
pastoral setting. Gentlemen did not sleep in
these fancy caps; they preferred to wear
plain cotton or wool versions, often quilted
for warmth.

Child's Head Protector ("pudding")
Quilted tan silk with maroon stripes,
 trimmed with maroon silk ribbon
Swiss, about 1740
The Metropolitan Museum of Art
Gift of Mrs. DeWitt Clinton Cohen, 1939
CI 39.61.7

Child's Head Protector ("pudding")
Quilted green leather edged with green silk
 ribbon and trimmed with green ribbon
 rosettes
Swiss (?), about 1740
The Metropolitan Museum of Art
Gift of Mrs. DeWitt Clinton Cohen, 1939
39.54.4

When children were learning to walk they
wore padded crowns to protect their tender
heads from harm if they fell. The caps were
made of rings of horsehair covered with
leather or fabric and trimmed with colored
ribbons. In England, these caps were called
"puddings" because of their shape.
According to A. Varron, a costume
historian, the term "in pudding and pinner
[pinafore]" was a metaphor expressing
extreme youth.

Man's Tricorne Hat
Black felt trimmed with silver metallic
 ribbon
German (?), mid-18th century
The Metropolitan Museum of Art
Gift of Lee Simonson, 1939
CI 39.13.244

Man's Tricorne Hat
Coarse black felt
American (?), mid-18th century
The Metropolitan Museum of Art
Gift of Miss Agnes Clarke, 1941
41.124.80

Man's Tricorne Hat
Black felt edged with black velvet, trimmed
 with black silk pompons and appliquéd
 black velvet; back held to crown with
 black silk cords; black velvet hatband
 with silver filigree buckle
Austrian, mid-18th century
The Metropolitan Museum of Art
Gift of Miss Agnes Clarke, 1941
41.124.79

Man's Tricorne Hat
Black felt trimmed with silver galloon and a
 black taffeta bow
Italian, mid-18th century
The Metropolitan Museum of Art
Rogers Fund, 1925
26.56.88

Circular "Flat" Hat
Tan straw woven with blue and purple silk
 ribbon and trimmed with polychrome
 silk ribbon in a floral design and silver
 metallic lace; very low crown
English, about 1750
The Metropolitan Museum of Art
Gift of Mrs. F. D. Millet, 1913
13.49.35

Hat
Ivory-colored wool trimmed with ivory-
 colored silk ribbon painted in rose and
 green in a floral and cone design, silver
 lace, fringe, and passementerie;
 underside covered with pink wool
French, about 1760
Lent by the Musée de la Mode et du
 Costume, Paris
SL 81.83.5

Calash
Brown silk on frame of cane
English, 3rd quarter of 18th century
The Metropolitan Museum of Art
Gift of Mrs. Aline Bernstein, 1938
CI 38.100.19

Man's Tricorne Hat
Black felt; brim held up by black tape and
 grosgrain button with metal fleur-de-lis
 design
French, about 1775
The Metropolitan Museum of Art
Gift of Mrs. William Martine Weaver, 1950
CI 50.8.16

Headdress
Pink and green ribbed silk embroidered
 with gold and silver thread in a floral
 and foliate design
French, about 1776
The Metropolitan Museum of Art
Gift of Mrs. Augustus Cleveland, 1903
03.1.4d

Since France and Spain were closely allied
by treaty and both were ruled by
descendants of Louis XIV, it is not
surprising that Spanish fashions were
periodically revived at the French court.
Mantillas in lace and velvet were popular
in 1729, and, at the time of the marriage of
the *dauphin* to a Spanish infanta in 1745,
many fashions were designated *à
l'espagnol*. This embroidered headdress is
from a later revival in the reign of Louis
XVI. It recalls the shape of net coifs worn
by the Spanish *moyos*, or dandies. Legend
holds that this hat was worn by Queen
Marie Antoinette.

Hat à la Harpie
Blond Italian straw with high crown,
 trimmed with pale green, pink, and
 ivory ribbons; underside covered with
 ivory-colored figured silk
French, about 1787
Lent by the Musée de la Mode et du
 Costume, Paris
SL 81.83.6

One of the chief occupations at any royal
court in the eighteenth century was political
intrigue. Princes and noblemen were
constantly seeking positions of power for
themselves and their political ambitions.
The court of Louis XVI was divided into
five factions: the queen's set; the adherents
of the Duc d'Orléans, who favored a
constitutional monarchy; the feudal
nobility, who wanted a figurehead king
dominated by the nobles and supported the
Comte d'Artois; and the followers of the
Comte de Provence, who had no ideology
other than a consuming desire to become
king. Each new political development found
expression in the many pamphlets
published illegally, and often in the fashions
worn by the rival groups. The Comte de
Provence detested his sister-in-law Marie
Antoinette and made up a story about her
in the guise of a harpy, a monster
supposedly discovered in Peru with two

horns and two tails. This fable was well known at Versailles, and fashions *à la harpie*, with ribbons cut with double points, were worn openly. The Musée de la Mode et du Costume also has a *robe à l'anglaise* with the same politically inspired silk trimming.

Man's Tricorne Hat
Black beaver trimmed with silver metallic ribbon; brown ribbed silk hatband
European, late 18th century
The Metropolitan Museum of Art
Gift of Mrs. M. M. Mouraille, 1938
CI 38.47.4

Circular "Flat" Hat
Leghorn straw
American, late 18th century
The Metropolitan Museum of Art
Anonymous Gift, 1939
CI 39.137

As early as 1727 a French visitor to London noted that the "small hats of straw are vastly becoming. Ladies of the highest rank are thus attired when they go walking or make a simple visit." These straw or "chip" hats were worn pinned or tied to the head, often over a white mull mobcap.

Man's Tricorne Hat
Black velour trimmed with metal and red silk gimp; gold grosgrain hatband
Italian, late 18th century
The Metropolitan Museum of Art
Rogers Fund, 1925
26.56.87

Stomachers and Corsets

Stomacher
White cotton quilted in a stylized foliate pattern, with diamond-shaped openings and white buttons covered with crocheted thread
English, about 1700
The Metropolitan Museum of Art
Purchase, Irene Lewisohn Bequest, 1974
1974.194.1

Stomacher
Natural linen embroidered with polychrome silks and metallic thread in a floral and vermicelli motif
English, about 1710
The Metropolitan Museum of Art
Purchase, Irene Lewisohn Bequest, 1956
CI 56.38.2

Stomacher
Rose-colored silk faille embroidered in a floral design with polychrome silks with silver metallic cord to simulate lacing, edged with silver braid
English, about 1720
The Metropolitan Museum of Art
Purchase, Irene Lewisohn Bequest, 1975
1975.206.1

Stomacher
Finely quilted white linen with a floral pattern outlined in saffron yellow
English, about 1720
The Metropolitan Museum of Art
Purchase, Irene Lewisohn Bequest, 1976
1976.235.2ab

Stomacher
Ivory-colored ribbed silk embroidered with polychrome silks and metallic thread in a floral pattern, ending in finger-shaped tabs
French, 2nd quarter of 18th century
The Metropolitan Museum of Art
Purchase, Irene Lewisohn Bequest, 1958
CI 58.29

Stomacher
Ivory-colored silk embroidered with polychrome silks and silver metallic thread in a floral pattern bordered in pink silk
Swiss or south German, 2nd quarter of 18th century
The Metropolitan Museum of Art
Purchase, Irene Lewisohn Bequest, 1980
1980.444.6

Stomacher
Natural linen embroidered with polychrome silks and silver metallic thread in a floral and *rocaille* pattern
English, about 1740
The Metropolitan Museum of Art
Purchase, Irene Lewisohn Bequest, 1970
1970.106.2

Stomacher
Natural cotton couched with silver metallic thread in a herringbone pattern, embroidered with polychrome silks in a floral pattern, and edged with natural cotton tape
English, mid-18th century
The Metropolitan Museum of Art
Purchase, Irene Lewisohn Bequest, 1962
CI 62.29.2

Stomacher
Cream-colored silk embroidered with polychrome silks and metallic thread in a floral pattern
Swiss, mid-18th century
Lent by Martin Kamer, Switzerland
SL 81.111.5

Corset
Blue watered silk trimmed with white braid and chamois tabs
English, mid-18th century
The Metropolitan Museum of Art
Gift of Mrs. Frank D. Millet, 1913
13.49.2

Stomacher
Tan silk brocade with a floral pattern in
 polychrome silks and metallic thread,
 trimmed with metallic lace
Italian, about 1770
Gift of The Metropolitan Museum of Art,
 1940
CI 40.173.6a

Corset and Stomacher
Blue silk brocade with a polychrome floral
 design edged in white leather with metal
 loops for lacing; matching stomacher,
 trimmed with gold lace and metallic
 braid
German (?), about 1770
The Metropolitan Museum of Art
Gift of Lee Simonson, 1939
CI 39.13.209ab

Gloves

Pair of Gloves
Cream-colored kid with an inset of gold
 netted lace and a border of matching
 grosgrain ribbon woven with a leaf
 motif in gold thread
French, early 18th century
The Metropolitan Museum of Art
Gift of Mrs. Benjamin G. Lathrop, 1952
CI 52.28ab

Pair of Mitts
Rose-colored silk embroidered in a rose
 floral pattern
European, early 18th century
The Metropolitan Museum of Art
Gift of Lee Simonson, 1944
44.8.7ab

Pair of Gloves
Knitted cream-colored cotton with
 openwork diamond pattern
American, early 18th century
The Metropolitan Museum of Art
Gift of Mrs. William Martine Weaver, 1949
CI 50.8.6ab

Pair of Mitts
Ivory-colored knitted silk with pink and
 green stripes, trimmed with silver
 metallic lace
English, early 18th century
The Metropolitan Museum of Art
Gift of Mrs. Frank D. Millet, 1913
13.49.11ab

Pair of Mitts
Rose-colored and green changeable silk
 with cuffs of rose-colored silk, trimmed
 with dark rose-colored braid and lined
 in green silk
German (?), about 1760
The Metropolitan Museum of Art
Gift of Lee Simonson, 1944
44.8.17ab

Pair of Mitts
Blue silk with rose-colored silk cuffs and
 rose-colored chenille embroidery
German (?), about 1760
The Metropolitan Museum of Art
Gift of Lee Simonson, 1944
44.8.18ab

Mitt
Golden-yellow silk embroidered with beige
 silk in a foliate and *rocaille* design
English, about 1770
The Metropolitan Museum of Art
Gift of the New-York Historical Society,
 1979
1979.346.5

Pair of Mitts
White cotton with a polychrome chinoiserie
 floral print
French, about 1775
The Metropolitan Museum of Art
Gift of Lee Simonson, 1939
CI 39.13.185cd

Pair of Gloves
White kid printed with purple stripes
Italian, about 1780
The Metropolitan Museum of Art
Rogers Fund, 1925
26.56.95–96

Pair of Gloves
White kid with an embroidered lady in
 pink, blue, and green silks and gold
 tinsel
English, about 1780
The Metropolitan Museum of Art
Rogers Fund, 1923
23.220.1–2

The embroidered figure on these gloves is a
lady in court dress complete with the
fontanges, the hairstyle in vogue during
the first decade of the eighteenth century.
It is unusual to find a historical costume
depicted on a fashionable accessory. It
must have amused the lady who wore the
gloves to compare the style of her
grandmother's day to the attire of her own
time.

Pair of Gloves
Blue kid
Austrian (?), late 18th century
The Metropolitan Museum of Art
Gift of Lee Simonson, 1938
CI 38.23.372ab

Pair of Gloves
Mustard-yellow kid
Italian, late 18th century
The Metropolitan Museum of Art
Rogers Fund, 1925
25.56.93–94

Pair of Gloves
White kid
Italian, late 18th century
The Metropolitan Museum of Art
Rogers Fund, 1925
26.56.91–92

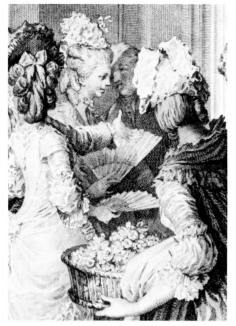

Fans

In the eighteenth century the fan was an indispensable part of a lady's costume. She would no more venture forth into society without this accessory than a modern woman would go without her handbag. A fan gave a lady something pretty to hold, cooled her in warm weather, and protected her delicate skin from the heat of the fireplace. Fans were made either totally of ivory or of a mixture of carved ivory and folding mounts of silk, vellum, or chicken skin. The last material was particularly popular for painted fans because of its smooth, opaque surface. In the second half of the century, painted fans often commemorated some current event like the Montgolfier balloon ascent or the fall of the Bastille, and thus were as timely as the other fashions worn by their owners. Fine lace was also mounted on fans. France had a major fan-making industry; in 1753 Paris alone supported 150 master fan makers. Many fans were also made in Italy, Spain, and England. The fan in the eighteenth century was a romantic adjunct to a lady's costume. By holding her fan in a certain manner, a lady could transmit a message to a gentleman on the other side of a room. For this form of communication to be successful, it was necessary for both sexes to know the code and also to live in a restricted society like that of the court of Versailles. The English poet Joseph

Addison made the following comments in *The Spectator* in 1711:

> Women are armed with fans as men with swords, and sometimes do more execution with them.... I have seen a fan so very angry that it would have been dangerous for the absent lover who provoked it to have come within the wind of it, and at other times so very languishing that I have been glad for the lady's sake that the lover was at a sufficient distance from it. I need not add that a fan is either a prude or a coquette, according to the nature of the person who bears it.

Fan
Ivory painted in gouache with a scene of birds, bordered with gilt and Chinese scenes, trimmed with ivory-colored grosgrain ribbon; mother-of-pearl on hilt
French or Dutch (?), 2nd decade of 18th century
The Metropolitan Museum of Art
Bequest of Mary Clark Thompson, 1923
24.80.17

Fan
White kid painted with a central human mask *(bauta)* surrounded by painted scenes of a fan shop, a chess-playing couple, a lady in a sedan chair, and musicians, with *rocaille* and floral borders; sticks and guards of carved, pierced, gilded, and painted ivory
Spanish, 1740–50
The Metropolitan Museum of Art
Gift of Miss Agnes Miles Carpenter, 1955
55.43.17

Fan
Point d'Angleterre bobbin lace with the arms of Ferdinand VI and Queen Maria Magdalena of Spain; mother-of-pearl sticks and guards pierced, carved, and painted with two tones of gold in a *rocaille* pattern, the royal Spanish arms, and *putti*; two diamonds in hilt; original green shagreen case trimmed with geometric copper-gilt nailheads
French about 1750
The Metropolitan Museum of Art
Gift of Mrs. Albert Blum, 1953
53.162.71ab

Fan
Paper painted in gouache and watercolor with Chinese figures grouped around a tea table; borders painted with a gold chinoiserie design; mother-of-pearl sticks and guards pierced, carved, and painted in tones of gold with *putti*, musicians, and garland-bearing figures
French, about 1765
The Metropolitan Museum of Art
Gift of Miss Isabel Shults, 1959
59.42.1

Fan
Parchment painted with a central medallion of figures in a landscape and two portrait medallions of Louis XVI and Queen Marie Antoinette surrounded by flowers, vases, sequined ribbons, birds, insects, and *rocaille* patterning; tortoiseshell sticks and guards pierced, carved, and painted in tones of gold with *putti* and human figures
Italian or French, about 1780
The Metropolitan Museum of Art
Gift of Miss Ella Mabel Clark, 1948
48.58.11

Fan
Parchment with a central gallant scene surrounded by polychrome-painted floral swags, trimmed with gold sequins and metallic braid; sticks and guards of pierced and gilded ivory with *putti* and garlands; paste stone in hilt
French, 1780s
The Metropolitan Museum of Art
Gift of Miss Agnes Miles Carpenter, 1955
55.43.9

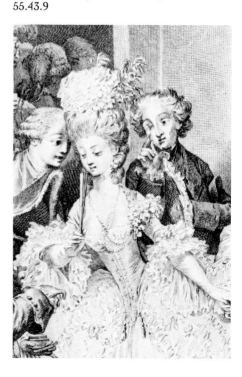

Fan
Painted silk with a central motif of a
 woman playing a harp, flanked by
 symbols of the arts, trimmed with gold
 and silver sequins; ivory sticks and
 guards with gold and silver leaf floral
 design
French (?), 1785
The Metropolitan Museum of Art
Gift of Margaret H. Bronson, 1955
CI 55.22.2

Bags

Bag
Cloth of silver with polychrome enamel
 plaques of a gentleman and a lady
European, about 1695
The Metropolitan Museum of Art
Gift of Mrs. Edward S. Harkness, 1930
30.135.176

Bag
Cloth of silver trimmed with rose moiré
 ribbon and silver fringe with
 polychrome enamel plaques of a
 gentleman and a lady
European, late 17th century
The Metropolitan Museum of Art
Gift of Mrs. Edward S. Harkness, 1930
30.135.175

Drawstring Bag
Red velvet trimmed with bands of gold
 galloon and an appliquéd embroidery
 motif of a flower; cords trimmed with
 tassels of red silk and metallic thread
French, early 18th century
The Metropolitan Museum of Art
Gift of Spencer Samuels, 1978
1978.244.3

In her memoirs, the Marquise de la Tour
du Pin commented on a bag, similar to this
one, used to hold the missal or prayerbook
she was handed on her way to mass at
Versailles:

> Then we would throw our trains on one
> side of our hooped skirts, and after
> having been noticed by one's footman,
> who was waiting with a big red velvet
> bag adorned with gold tassels, we would
> rush into the rows on the right and left
> of the chapel so as to be as close as
> possible to the balcony where the King
> and Queen and princes who had joined
> them . . . were gathered. Your footman
> would put your bag in front of you; you
> would take out your book, which you
> hardly used since by the time you had

arranged your train and looked through
the huge bag, the masses had already
reached the Gospel.

Round Bag
Lilac silk brocade in polychrome floral and
 meander pattern, trimmed with blue and
 white silk cord and tassel
Austrian, 18th century
The Metropolitan Museum of Art
Gift of Lee Simonson, 1938
38.23.110

Gaming Bag (bourse de jeux)
Blue velvet couched in silver and gold
 thread, with the royal arms of France
 and Navarre and a small *L* (possibly for
 Louis XV); lined in white kid
French, mid-18th century
The Metropolitan Museum of Art
Gift of Mrs. Edward S. Harkness, 1930
30.135.178
Detail illustrated, page 6

Gambling was one of the principal evening
diversions at Versailles, with huge sums
won and lost by the courtiers. One mark of
favor was to carry money in a gaming bag
or *bourse de jeux*. This was a small velvet
bag lined in white kid and often covered
with thin silk. The owner's coat of arms
was embroidered on the bottom of the bag
in polychrome silks and gold and silver
metallic threads. The king presented such a
bag, filled with gold coins, to members of
his family and to courtiers whom he wished
to honor.

Gaming Bag (bourse de jeux)
Dark green velvet couched in silver and
 gold metallic thread and blue and rose-
 colored silks with the coat of arms of
 the Marquis de Chalmazel
French, about 1750
Lent by a private collection, Paris
SL 81.86.3

Gaming Bag (bourse de jeux)
Dark green velvet couched in silver and
 gold metallic thread and blue and rose-
 colored silks with the arms of Queen
 Maria Leczinska
French, about 1750
Lent by a private collection, Paris
SL 81.86.2

Gaming Bag (bourse de jeux)
Red velvet couched in silver metallic thread
 with the arms of the Comte d'Argenson
French, about 1750
Lent by a private collection, Paris
SL 81.86.1

Folding Purse
Linen completely covered with wool
 embroidery in green with a polychrome
 floral pattern in crewelwork and chain
 stitch
American, about 1750
The Metropolitan Museum of Art
Gift of Claggett Wilson, 1946
46.59.2

Folding Purse
Linen needlepointed in a polychrome flame-
 stitch pattern
English, last quarter of 18th century
The Metropolitan Museum of Art
Gift of Virginia S. Mayor, 1980
1980.592.1

Folding Purse
Cream-colored silk with appliquéd
 medallions embroidered in polychrome
 silks, trimmed in silver metallic thread
French, late 1780s
The Metropolitan Museum of Art
Gift of Catherine Oglesby, 1959
CI 59.30.2

Flat Purse
White satin painted in a military-trophy
 and strawberry-vine motif
French, about 1790
The Metropolitan Museum of Art
Gift of Catherine Oglesby, 1959
CI 59.30.1

Flat Purse
Red leather embroidered with a diamond-
 shaped design in silver thread
Austrian (?), late 18th century
The Metropolitan Museum of Art
Gift of Lee Simonson, 1939
39.13.274

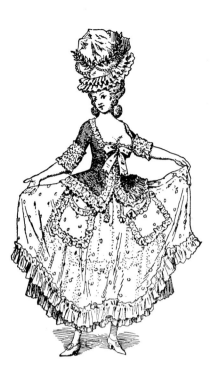

Aprons

Apron
Off-white silk moiré and cloth of silver
 with blue stripes woven horizontally,
 trimmed with blue silk and gold metallic
 braid
Italian, about 1700
The Metropolitan Museum of Art
Purchase, funds from various donors, 1980
1980.408.4

Elaborate aprons in silks and metallic
fabrics of the seventeenth century
continued to be worn as luxurious
accessories in the succeeding century. These
aprons served no practical purpose; rather,
they added variety to a fashionable
woman's wardrobe by altering the lines and
colors of her costume.

Apron
Ivory-colored silk embroidered with gold in
 a foliate and star pattern
English, early 18th century
The Metropolitan Museum of Art
Purchase, Irene Lewisohn Bequest, 1962
CI 62.29.3

Apron
Cream-colored taffeta embroidered with
 polychrome silks in a floral pattern,
 edged with metallic lace
English, 1st quarter of 18th century
The Metropolitan Museum of Art
Purchase, Irene Lewisohn Bequest, 1964
CI 64.34

Apron
Ivory-colored taffeta embroidered with
 green and red silks and silver metallic
 thread in a foliate and floral pattern
English, about 1740
The Metropolitan Museum of Art
Purchase, Irene Lewisohn Bequest, 1971
1971.95

Apron
Ivory-colored passementerie trimmed with
 ombréd blue grosgrain ribbon, bands of
 blue fly-fringe, and white blonde lace
French, about 1740
The Metropolitan Museum of Art
Gift of Polaire Weissman, 1979
1979.436

Apron
Apple-green taffeta trimmed with rose and
 silver metallic ribbons
French, mid-18th century
The Metropolitan Museum of Art
Purchase, Irene Lewisohn Bequest, 1971
1971.242.6

Apron
Mustard-yellow cotton printed with a
 polychrome foliate and gourd design;
 bib trimmed with red and ivory-colored
 striped silk ribbon
English, about 1750
Lent by the Chicago Historical Society
SL 81.69.3

Shoes

Pair of Shoes
White kid embroidered with green and
 yellow silks and silver metallic thread in
 a foliate pattern; red leather heels
French, about 1695
The Metropolitan Museum of Art
Rogers Fund, 1906
06.1344

Pair of Shoes and Pattens
White linen embroidered in blue silk;
 pattens of brown leather with blue
 brocade straps
English, 1st quarter of 18th century
The Metropolitan Museum of Art
Gift of Mrs. Max Schott, 1952
CI 52.15.2a–d

Pair of Shoes
Green, pink, and cream-colored silk floral
 brocade trimmed with green silk ribbon;
 high heels
English, 1st quarter of 18th century
Lent by Cora Ginsburg,
 Tarrytown, New York
SL 81.68.11ab

Pair of Man's Court Shoes
White leather; red leather heels
Danish, about 1730
Lent by the Rosenborg Palace, Copenhagen
SL 81.81.6ab

Pair of Shoes
Ivory-colored satin embroidered with
 matching silk thread, trimmed with
 ivory-colored silk ribbon and matching
 fringe
English, about 1730
Lent by the Museum of the City of New
 York
SL 81.96.1ab

Pair of Slippers
Rose-colored silk brocade trimmed with
 metallic lace and edged with green silk
 ribbon; high red leather heels
French, about 1735
The Metropolitan Museum of Art
Gift of Miss Agnes Clarke, 1935
CI 38.76.5ab

Ladies and gentlemen at the French court
in the time of Louis XIV were required to
wear red leather heels —*les talons
rouges*. The fashion soon spread to the
major courts of Europe, where it was
followed until the end of the eighteenth
century. It is rare to find a surviving pair
of shoes of this quality. Most such footwear
must have been worn out and discarded;
court life consisted of endless standing,
since the right to sit down was rigidly
governed by etiquette.

Pair of Shoes
Polychrome wool needlepointed in a
 geometric pattern, trimmed with blue
 silk and turquoise brocade ribbon; heels
 covered with ivory-colored silk painted
 in a green, pink, and black foliate
 pattern
English, about 1735
Lent by The Brooklyn Museum
SL 81.74.3ab

Pair of Shoes
Polychrome silks queenstitched in a floral
pattern on a cream-colored ground,
trimmed with light blue ribbon; high
heels covered in dark blue wool
English, about 1735
Lent by the National Museum of American
History, Smithsonian Institution
SL 81.92.3

Pair of Shoes
Green silk brocade with a lighter green
foliate design trimmed with dark green
silk tape
English (?), mid-18th century
The Metropolitan Museum of Art
Gift of Mrs. Dudley Wadsworth, 1941
41.161.4ab

Pair of Baby's Court Shoes
White satin with red leather heels
Danish, mid-18th century
Lent by the Rosenborg Palace, Copenhagen
SL 81.81.7ab

In the eighteenth century the courts of
Europe were governed by a rigid etiquette,
with one's position in the system dependent
on noble birth or subsequent elevations. A
courtier bowed as reverently to a royal
prince in his cradle as he would to an adult
prince. These white leather shoes, with
their obligatory red leather heels, were
worn by an infant Danish prince; he was
dressed in the complete trappings of his
rank, albeit in miniature.

Child's Patten ("mud shoe")
Wooden sole with brown leather strap on
curved metal raise
English, mid-18th century
Lent by the Art Institute of Chicago
SL 81.98.1

Pair of Shoes
Pale blue satin edged with matching silk
tape
English, about 1750
The Metropolitan Museum of Art
Bequest of Mrs. Maria P. James, 1911
11.60.198ab

Pair of Mules
Green brocade with metallic *rocaille*
decoration, trimmed with pink silk
German (?), about 1750
The Metropolitan Museum of Art
Bashford Dean Memorial Collection, funds
from various donors, 1929
29.158.887ab

Pair of Shoes
Maroon leather with a cut-steel buckle,
trimmed with rose-colored silk ribbon;
high heels.
French, about 1750
The Metropolitan Museum of Art
Purchase, Irene Lewisohn Bequest, 1963
CI 63.35.6ab

Pair of Mules
Pale blue suede embroidered with pink and
green floss in a pomegranate and grape
design, piped in pale coral silk ribbon;
tan leather heels
French, about 1750
The Metropolitan Museum of Art
Gift of Bally of Switzerland, 1978
1978.356ab

Pair of Shoes
Rose-colored suede embroidered with silver
thread in a *rocaille* pattern, trimmed
with white silk ribbon; high white
leather heels
French, about 1750
Lent by the Musée de la Mode et du
Costume, Paris
SL 81.83.9ab

Patten ("mud shoe")
Wooden sole with brown leather straps
mounted on a circular iron raise
American, about 1750
Lent by the Chicago Historical Society,
SL 81.69.1ab

Pattens were worn out of doors by middle-
class ladies to protect their fine leather and
cloth shoes from mud and rubbish in the

streets. Fine shoes often had matching clogs
with flat bottoms and a sculpted instep.
Both clogs and pattens were tied securely
across the arch of the foot with colored
ribbons.

Pair of Shoes
Green silk brocade with a pink floral
design, trimmed with silver metallic lace
French, about 1760
The Metropolitan Museum of Art
Rogers Fund, 1914
14.63.1–2

Pair of Shoes
Pale blue silk with a floral design in black
purl and silver sequin appliqué; white
satin heels and trim
English, about 1776
The Metropolitan Museum of Art
Gift of Mrs. Frank D. Millet, 1913
13.49.30ab

Pair of Shoes
Purple silk with an appliquéd sequin-bow
design; low white leather heels
French, about 1780
The Metropolitan Museum of Art
Gift of Mrs. William Martine Weaver, 1950
CI 50.8.24ab

Pair of Shoes
Ivory-colored satin brocaded with
polychrome silks in a floral pattern; low
heels
English, about 1780
Lent by Cora Ginsburg,
Tarrytown, New York
SL 81.68.9ab

Pair of Shoes
Red leather trimmed with white silk
 grosgrain ribbon; high white leather
 heels
English (?), about 1780
Lent by The Brooklyn Museum
SL 81.74.2ab

Pair of Shoes
Black figured silk trimmed with matching
 ribbon; high white leather heels
Swedish, about 1780
Lent by the Nordiska Museum, Stockholm
SL 81.91.1ij

Pair of Shoes
Green silk damask woven in white in a
 foliate and floral pattern; white satin
 heels
English, about 1780 (fabric earlier)
Lent by the Museum of the City of New
 York
SL 81.96.2ab

Pair of Shoes
Dark green satin couched with silver
 metallic thread and silver sequins in a
 floral and *rocaille* design, trimmed with
 pink silk ribbon; medium pink satin
 heels
French, about 1780
Lent by Martin Kamer, Switzerland
SL 81.111.2ab

Pair of Shoes
Dark green satin trimmed with matching
 silk ribbon; medium heels
English, about 1780
Lent by Martin Kamer, Switzerland
SL 81.111.3ab

Pair of Mules
Pink figured silk embroidered with silver
 sequins and pearl beads in a floral-vine
 design; white leather heels
French, about 1780
Lent by the Musée Carnavalet, Paris
SL 81.88.1ab

These embroidered mules are said to have
been worn by Queen Marie Antoinette.
They were given to the Carnavalet by
Princess Eudoxie of Bulgaria, a direct
descendant of Charles X, brother-in-law of
the queen.

Pair of Shoes
Blue figured silk embroidered with metallic
 thread in a foliate design, trimmed with
 ivory-colored silk ribbon and padded
 bows, gold lace, and silver sequins;
 white kid heels
German, about 1780
The Metropolitan Museum of Art
Gift of Lee Simonson, 1939
CI 39.13.257ab

Pair of Shoes
White kid trimmed with purple satin bows
 and piping
Attributed to Joseph Wolff
French, about 1783
Lent by a private collection, Paris
SL 81.112.2ab

These shoes were made for Queen Marie
Antoinette by her German master
shoemaker, Joseph Wolff. Preserved by
Madame du Crey, keeper of the queen's
lace, and, later, her descendants, they were
sold to the family of the present owners
during the Second Empire.

Pair of Shoes
Pale blue satin trimmed with matching silk
 ribbon; low molded heels
English, about 1785
Lent by Martin Kamer, Switzerland
SL 81.111.8ab

Pair of Shoes
Green damask in a foliate pattern, trimmed
 with olive-green silk ribbon; low light
 green leather heels
English, about 1790
Lent by Martin Kamer, Switzerland
SL 81.111.4ab

Pair of Shoes
White satin; pink satin trim and heels
English, late 18th century
The Metropolitan Museum of Art
Gift of Mrs. Frederick Street Hoppin, 1963
CI 63.7.6ab

Miscellaneous Accessories

Busk
Wood with inlaid decoration of foliate
 scrolls, hearts, and bird; *ZG* monogram
Dutch or German, about 1700
The Metropolitan Museum of Art
Gift of Mrs. Edward S. Harkness, 1930
30.135.22

A curved wooden busk, used to stiffen the
bodice, was inserted between the breasts
into an opening in the front of the corset.
Busks were often elaborately trimmed with
inlays of rare wood or mother-of-pearl. It
was characteristic of the time that elaborate
effort and craftsmanship were expended on
the decoration of an object that was rarely
seen.

**Parasol (copy of original in Costume
 Institute collection)**
Ivory-colored silk faille embroidered with
 polychrome silks and gold metallic
 thread in a floral and *rocaille* pattern,
 trimmed with gold metallic braid and
 fringe and ivory-colored silk and gold
 tassels
Italian, 1st quarter of 18th century
The Metropolitan Museum of Art
Gift of Irwin Untermyer, 1946
46.29a–c

Muff
White grebe feathers, lined with dark
 brown satin and fleece
Danish, about 1740
Lent by the Rosenborg Palace, Copenhagen
SL 81.81.8

Queen Louise of Denmark, wife of
Frederick V and daughter of George II of
Great Britain and Hanover, carried this
wool-lined muff and probably valued its
warmth in cold palace rooms during the
Baltic winter. Muffs were fashionable
accessories for both men and women. They
were small at the beginning of the century
but, by the 1790s, had grown quite large.
They were generally made of silk or
feathers lined in wool or in one of the
fashionable furs: ermine, chinchilla, fox,
sable, kolinsky, or beaver. The long, silky
hair of the angora goat was also used. In
England during the 1790s the muff played
a political role: supporters of the statesman
Charles James Fox carried oversized fox
muffs to proclaim their political preference.

Woman's Mask (bauta)
Shiny white plaster
Italian, mid-18th century (?)
The Metropolitan Museum of Art
Gift of Mrs. DeWitt Clinton Cohen, 1943
43.43.2

Eighteenth-century Venetians devised a masquerade costume that was uniquely their fashion. It consisted of a black taffeta hood edged with a wide band of lace and called a *tabarro* if worn by a gentleman and a *tabarrino* if worn by a lady. A pasteboard fancy-dress mask, modeled on the monkey masks used by the actors of the Commedia dell'Arte, was worn with this hood. The masks, or *bautas*, were worn by both sexes. Black oval masks called *morettas* were also used by ladies as a disguise. These resembled the complexion masks that women had worn out of doors in the seventeenth century. Since the *bauta* or *moretta* covered half the face, the wearer enjoyed a large measure of anonymity which allowed him or her to talk confidentially or to act indiscreetly. One need only remember the exploits of Casanova to imagine the many uses of the disguise. The Venetian Council of Ten, however, restricted the wearing of this costume to the period between the first Sunday in October and the beginning of Lent, and to special holidays like the day of the election of a doge. These occasions, and the masquerades worn, are amply recorded in the contemporary paintings of Longhi and Tiepolo.

Man's Mask (bauta)
Shiny white plaster
Italian, mid-18th century (?)
The Metropolitan Museum of Art
Gift of Mrs. DeWitt Clinton Cohen, 1943
43.43.1

Servant's Wig
White horsehair with black cotton bag
 (crapaud)
Italian, mid-18th century
The Metropolitan Museum of Art
Rogers Fund, 1926
26.56.147

Fine wigs were made of human hair that was "neither too coarse, nor too slender, the bigness rendering it less susceptible of the artificial curl and disposing it rather to frizzle, and the smallness making its curl too short." Less expensive wigs, like this servant's wig from Venice, were made of horsehair, goat's hair, or even feathers. Wigs were powdered with scented flour, which adhered to the hair by means of grease or pomatum. The process of powdering was very messy, so special "powder rooms" were designed. Wigs could

also be sent to the local wig maker to be recurled and powdered. Gentlemen must have always had a sprinkling of flour on the shoulders of their garments, a flaw usually omitted in contemporary portraits.

Pair of Pockets
White satin embroidered with green, red, and white silks in a strawberry pattern edged with yellow silk
English, mid-18th century
The Metropolitan Museum of Art
Purchase, Irene Lewisohn Bequest, 1974
1974.101.1

Petticoat
Chartreuse silk with wide stripes of white quilted in floral and *rocaille* design and edged with darker green tape
English, mid-18th century
The Metropolitan Museum of Art
Purchase, Irene Lewisohn Bequest, 1977
1977.197.2

Hoop (pannier)
Natural glazed cotton with wicker hoops and white cotton ties
English, about 1750
The Metropolitan Museum of Art
Purchase, Irene Lewisohn Bequest, 1973
1973.65.2

Panniers, which helped to support the weight of voluminous dresses, usually rested on two small hip pads on either side of the corset. Despite the many inconveniences caused by the pannier, it was an indispensable element of dress from 1720 to the time of the French Revolution. Satirists and playwrights severely criticized the wearing of this undergarment, but without effect. In the comedy *Les Paniers de la vieille piecieuse* of 1744, Harlequin sold panniers in the street with the cry, "I have sold ones which can be raised for prudes, folding ones for gallant ladies, and half-and-half models for members of the Third Estate [the bourgeoisie]."

Double Sleeves (engageantes)
White mull with *broderie anglaise* and lace insets in *rocaille* forms
English, about 1760
Lent by The Brooklyn Museum
SL 81.74.4a–d

Scarf
White silk trimmed with green and pink silk flowers alternating with *rocaille* shapes in silver thread; edged with silver lace
French, about 1760
The Metropolitan Museum of Art
Purchase, Irene Lewisohn Bequest, 1980
1980.444.7

Pair of Garters
Green and salmon-colored silk and gold metallic brocade trimmed with salmon-colored silk ruching and ivory-colored silk ribbon
French (?), 1772
Lent by the Rosenborg Palace, Copenhagen
SL 81.81.9cd

Pair of Garters
Pale blue and white zigzag-striped silk braid trimmed with pale blue figured silk ribbon
French (?), 1772
Lent by the Rosenborg Palace, Copenhagen
SL 81.81.9ab

Christian VII of Denmark married an English princess, Caroline-Mathilde, daughter of the Prince of Wales and sister of George III. The Danish king suffered from a form of mental illness and was extremely erratic in his behavior. The young queen felt quite isolated from her husband and, after the birth of a crown prince, she withdrew from him and his dissolute courtiers. A German doctor, Johann Friedrich Struensee, was able to reason with Christian, thus gaining influence with the king and the lonely queen. He soon became the queen's lover in an almost public liaison. Struensee was a partisan of the philosophies of Rousseau and Helvétius — radical ideas that had little following in Denmark. Through court intrigue and their influence over Christian VII, the queen and the doctor were able to have the king's first minister, Bernstoff, replaced by Struensee in 1770. Since the king was deranged during this period, Struensee was the virtual ruler of the country. The Danish nobility tolerated this situation only until Struensee tried to introduce liberal political reforms. Then they convinced the weak-willed Christian VII to order the arrest of his wife and the prime minister. These silk garters, presents from Struensee to the queen, were used by the prosecution as evidence of the intimate nature of their relationship. Struensee was condemned to death and was barbarously broken on the wheel in a public square in Copenhagen on April 26, 1772. The queen, because of her position and family ties, was merely exiled to a remote castle in Celle (Hanover). Nicknamed the "Queen of Tears," she died in exile at twenty-four.

Men's Shoe Buckles
Paste and goldstone set in silver
American, about 1775
The Metropolitan Museum of Art
Gift of Mrs. Carman Messmore, 1981
1981.104ab

Hunting Belt
Brown leather stamped in a gold scroll and
 floral design
French, about 1780
Lent by a private collection, Paris
SL 81.112.1

Louis XVI was a true Bourbon monarch in
his devotion to the hunt, his favorite
pastime. On days when the king was
prevented from hunting, his diary entries
tersely noted: "Today, nothing." Marie
Antoinette hunted infrequently. There were
times, however, when she was obligated by
court etiquette to follow the hunt, for
which she wore a riding coat cut in
imitation of a man's coat, and this brown
leather belt. Madame du Crey, keeper of
the queen's lace, preserved the belt at the
time of the Revolution. Her descendants
sold it to the family of the present owner
during the Second Empire.

Buttons
Figures of *amorini* painted on ivory in
 grisaille with gilt-metal mounts;
 original leather case lined in blue-green
 plush
French, about 1780–90
The Metropolitan Museum of Art
Gift of Susan Dwight Bliss, 1942
42.118.1–15

Watch Fob
Green braid embroidered in metallic thread
 with a painted miniature of a *putto*;
 gilt tassels and a brass key
French, about 1780
The Metropolitan Museum of Art
Anonymous Gift, 1924
24.166.16

Buttons
Four Italian perfume buttons; silver-
 mounted miniatures on ivory; three
 French portrait buttons of ladies painted
 on silk, under glass; eleven French
 buttons with military and revolutionary
 subjects painted in gouache on paper,
 under glass
About 1780
The Metropolitan Museum of Art
From the Hanna S. Kohn Collection, 1950
50.23.1–637

Collarette
Black silk ribbon and lace
French, 1784
Lent by the Musée Carnavalet, Paris
SL 81.88.2

This black lace collarette was worn by
Marie Antoinette when she sat for her
miniature portrait by Nicolas-Antoine-
Laurent Dumont in 1784. The queen gave
this accessory to the artist to help him
complete her portrait, and it was treasured
by generations of his descendants, who
later gave it to the Carnavalet.

Watch Fob
Three flat gold filigree chains with a blue
 enamel medallion, a flat watch key, urn-
 shaped and agate charms, and a red
 carnelian seal
German, about 1795
The Metropolitan Museum of Art
Anonymous Gift, 1924
24.166.2

Pair of Pockets
Tan linen embroidered with polychrome
 silks in a floral-vine pattern with the
 monogram *MP* and the date
American, 1796
The Metropolitan Museum of Art
Gift of the New-York Historical Society,
 1979
1979.346.4

"Pockets" held a lady's handkerchief, keys,
money, or love letters. A lady put her
hands through the side slits in her
overdress to reach her pockets, which were
worn tied around the waist under her
panniers. These bags were made in a
variety of sturdy materials, often covered
with silk and embroidered in fanciful
patterns.

Tabarrino
Black silk hood trimmed with black lace
Italian (Venetian), late 18th century
The Metropolitan Museum of Art
Rogers Fund, 1926
26.56.61

Buttons
White porcelain in a basketweave pattern
 with silver-gilt mounts; original leather
 case lined in green plush
English, late 18th century
The Metropolitan Museum of Art
Gift of Susan Dwight Bliss, 1942
42.118.16–24

Watch Fob
Round braid and tassel of polychrome silks
 and metal thread with a red glass
 pendant key and button of repoussé
 silver set with green and red stones
French, late 18th century
The Metropolitan Museum of Art
Anonymous Gift, 1924
24.166.23

Watch Fob
Gold braid with green silk and gold thread
 tassels and a green glass pendant key
French, late 18th century
The Metropolitan Museum of Art
Anonymous Gift, 1924
24.166.20

Watch Fob
Gilt braid with three gilt tassels and an
 amethyst pendant
French, late 18th century
The Metropolitan Museum of Art
Anonymous Gift, 1924
24.166.18

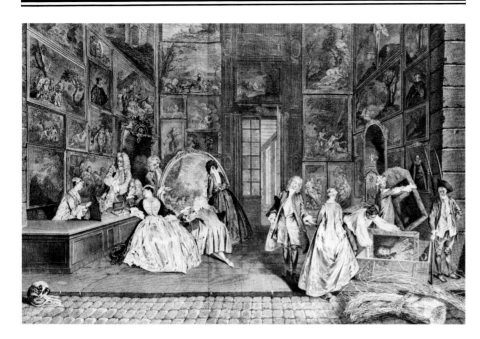

PAINTINGS

**Attributed to Hyacinthe Rigaud
(1659–1743)**
**Portrait of a Nobleman, Possibly
François de Chambrier**
Oil on canvas, oval, 32½ x 25¾ in. (81.6 x
65.4 cm.)
French, about 1705
The Metropolitan Museum of Art
Bequest of Catherine D. Wentworth, 1948
48.187.733

Pierre Gobert (1662–1744)
**Marie Adélaide de Savoie, Duchesse de
Bourgogne**
Oil on canvas, oval, 28 ¾ × 23 ¼ in.
(73 ×59.1 cm.)
French, 1710
The Metropolitan Museum of Art
Gift of the Marquis de la Begassière,
1963
1963.63.120

Magaretta Haverman (active 1716–50)
A Vase of Flowers
Oil on wood, 31¼ x 23¾ in. (79.4 x 60.3
cm.)
Dutch, 1716
The Metropolitan Museum of Art
Purchase, 1871
71.6

Portrait of a Man in a Brown Coat
Oil on canvas, oval, 28¾ x 23¼ in. (73 x
59.1 cm.)
French, 1st quarter of 18th century
The Metropolitan Museum of Art
Bequest of Catherine D. Wentworth, 1948
48.187.732

Portrait of a Lady in a Rose Dress
Oil on canvas, oval, 28½ x 23¼ in. (72.4 x
59.1 cm.)
French, 1st quarter of 18th century
The Metropolitan Museum of Art
Bequest of Catherine D. Wentworth, 1948
48.187.731

Peter Jacob Horemans (1700–1776)
**A Musical Gathering at the Court of the
Elector Karl Albert of Bavaria**
Oil on canvas, 34½ ×42 in. (87.6 × 106.7
cm.)
Flemish, 1730
The Metropolitan Museum of Art
Giovanni P. Morosini Collection, presented
by his daughter Giulia, 1932
32.75.4

**Pierre-Louis Dumesnil the younger
(1698–1781)**
Interior with Card Players
Oil on canvas, 31 ⅛ × 38 ¾ in.
(79 × 98 cm.)
French, about 1730
The Metropolitan Museum of Art
Bequest of Harry G. Sperling, 1971
1976.100.8

Nicolas de Largillière (1656–1746)
**Louis Guiguer, Baron de Prangins
(1675–1747)**
Oil on canvas, 54¼ × 41⅝ in.
(137.8 × 105.7 cm.)
French, about 1730
The Metropolitan Museum of Art
Rogers Fund, 1921
21.85.2

Nicolas de Largillière (1656–1746)
Judith van Robais, Baroness de Prangins
Oil on canvas, 54 ⅜ × 41½ in.
(138.1 × 105.4 cm.)
French, about 1730
The Metropolitan Museum of Art
Rogers Fund, 1921
21.85.2

Charles Philips
The Strong Family
Oil on canvas, 29 ⅝ × 27 in. (75.2 × 94
cm.)
English, 1732
The Metropolitan Museum of Art
Gift of Robert Lehman, 1944
44.159

Louis Toqué (1696–1772)
Queen Maria Leczinska
Oil on canvas, 106 ¾ × 76 in.
(271 × 193 cm.)
French, 1740
Lent by the Musée National du Château de
Versailles
SL 81.82.2
Illustrated, page 19

Maria Leczinska was a Polish princess
whose father, King Stanislas, had been
exiled to the small garrison town of
Weissenburg, in French Alsace, when she
was an adolescent. When the young Louis
XV was searching the courts of Europe for
a bride, a list of ninety-nine candidates was
drawn up. Political suitability and the
apparent scarcity of Catholic princesses of
marriageable age made the poor Polish
princess the preferred candidate. Queen
Maria often told the story of how she
learned of this extraordinary event. She
and her mother were preparing bundles of
clothing for charity in Weissenburg when
her father rushed into the room bearing a
letter.

"My daughter, let's fall on our knees and give thanks to God!"

"Why, Father? Have you returned to Poland as king?"

"No, Heaven has vouchsafed us a still greater boon: you are to be queen of France!"

Louis XV was very fond of his queen, but her exaggerated piety and simple tastes bored him; he treated her with kindness, but preferred the company of his mistresses. Louis Toqué, in this replica of his original painting in the Louvre, has portrayed the queen in a *grand panier* court dress with some of the crown jewels sprinkled across her stomacher and in her powdered hair. The ermine robe is a painter's conceit to show the sitter's rank, as the queen would not have worn a cape with her court dress, and certainly not one lined in ermine and embroidered with fleurs-de-lis, a costume reserved for coronations.

Attributed to Francesco Guardi (1712–1793)
Still Life
Oil on canvas, 72 × 36 in. (182.8 × 91.4 cm.)
Italian, about 1740
The Metropolitan Museum of Art
Gift of Mr. and Mrs. Charles Wrightsman, 1964
64.272.1

Attributed to Francesco Guardi (1712–1793)
Still Life
Oil on canvas, 72 × 36 in. (182.8 × 91.4 cm.)
Italian, about 1740
The Metropolitan Museum of Art
Gift of Mr. and Mrs. Charles Wrightsman, 1964
64.272.2

Bartholomew Dandridge (1691–1754)
The Price Family
Oil on canvas, 40¼ × 62½ in. (102.2 × 158.8 cm.)
English, about 1740
The Metropolitan Museum of Art
Rogers Fund, 1920
20.40

Antonio Joli (ca. 1700–1777)
London: Saint Paul's and Old London Bridge
Oil on canvas, 42 × 47 in. (106.7 × 119.3 cm.)
Italian, ca. 1744–54
The Metropolitan Museum of Art
Bequest of Alice Bradford Woolsey, 1970
1970.212.2

George Christoph Grooth (1716–1749)
The Empress Elizabeth of Russia on Horseback, Attended by a Page
Oil on canvas, 31⅜ × 24½ in. (79.7 × 62.2 cm.)
German, about 1745
The Metropolitan Museum of Art
Gift of Mr. and Mrs. Nathaniel Spear, Jr., 1978
1978.554.2

James Seymour (1702–1752)
Portrait of a Horseman
Oil on canvas, 37 × 51⅝ in. (94 × 131.1 cm.)
English, 1748
The Metropolitan Museum of Art
Gift of the children of the late Otto H. and Addie W. Kahn (Lady Maud E. Marriott, Mrs. Margaret D. Ryan, Roger W. Kahn, and Gilbert W. Kahn), 1956
56.54.1

François-Hubert Drouais (1727–1775)
Princess Sophie of France
Oil on canvas, 25⅝ x 20⅞ in. (65.1 x 53 cm.)
French, 1762
The Metropolitan Museum of Art
Gift of Barbara Lowe Fallass, 1964
64.159.1

Christian Wilhelm Ernst Dietrich (1712–1774)
Surprised, or Infidelity Found Out
Oil on canvas, 21⅝ × 28¾ in. (54.9 × 73 cm.)
German, about 1765
The Metropolitan Museum of Art
Purchase, 1871
71.162

Laurent Pécheux (1729–1821)
Maria Luisa of Parma, Later Queen of Spain
Oil on canvas, 90⅞ × 64¾ in. (230.8 × 164.5 cm.)
French, about 1767
The Metropolitan Museum of Art
Bequest of Annie C. Kane, 1926
26.260.9

François-Hubert Drouais (1727–1775)
Portrait of a Woman as a Vestal Virgin
Oil on canvas, 33 x 25½ in. (83.8 x 64.8 cm.)
French, 1767
The Metropolitan Museum of Art
Gift of Mrs. William M. Haupt, from the collection of Mrs. James B. Haggin, 1965
65.242.2

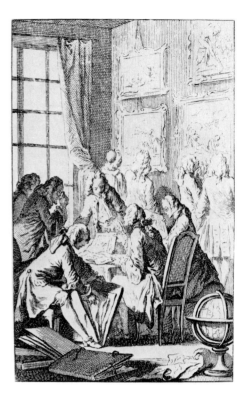

George Knapton (1698–1778)
Miss Rich Building a House of Cards
Oil on canvas, 30⅛ × 25¼ in. (76.5 × 68.6 cm.)
English, about 1770
The Metropolitan Museum of Art
Gift of Henry G. Marquand, 1890, Marquand Collection
91.26.1

Johann Eleasar Zeizig Schenan (1737–1806)
French Domestic Scene
Oil on canvas, 18 × 14⅞ in. (45.7 × 37.8 cm.)
German, about 1775
The Metropolitan Museum of Art
Bequest of Edward Fowles, 1971
1971.115.6

Angelica Kauffmann (1741–1807)
Edward Stanley (1752–1834), Twelfth Earl of Derby, with His First Wife (Elizabeth Hamilton, d. 1797) and Their Son (Edward Smith Stanley, 1775–1851)
Oil on canvas, 50 × 40 in. (127 × 101.6 cm.)
Swiss, about 1776
The Metropolitan Museum of Art
Gift of Bernard M. Baruch in memory of his wife, Annie Griffen Baruch, 1959
59.189.2

Frédéric Schall (1752–1825)
Mademoiselle Duthé
Oil on wood, 12¾ × 9¼ in. (32.4 × 23.5 cm.)
French, about 1778
The Metropolitan Museum of Art
Gift of Mrs. William M. Haupt, from the collection of Mrs. James B. Haggin, 1965
65.242.8

Philipp Jakob Loutherbourg the younger (1740–1812)
Fête of the Tunny Fishers at Marseilles
Oil on canvas, 33 × 48 in. (82.8 × 121.9 cm.)
French, about 1780
The Metropolitan Museum of Art
Purchase, 1871
71.81

Gainsborough Dupont (1754–1797)
Charlotte, Queen of England (1744–1818)
Oil on canvas, 23¾ × 17½ in. (60.4 × 44.5 cm.)
English, about 1780
The Metropolitan Museum of Art
The Jules Bache Collection, 1949
49.7.55

Marie Victoire Lemoine (1754–1820)
Madame Vigée-Lebrun and Her Pupil Mademoiselle Lemoine
Oil on canvas, 45⅞ × 35 in. (116.5 × 88.9 cm.)
French, about 1780
The Metropolitan Museum of Art
Gift of Mrs. Thornecroft Ryle, 1957
57.103

George Romney (1734–1802)
The Honorable Mrs. Tickell
Oil on canvas, 30 × 25⅛ in. (76.2 × 63.8 cm.)
English, about 1780
The Metropolitan Museum of Art
Bequest of Maria DeWitt Jesup, from the collection of her husband, Morris K. Jesup, 1915
15.30.36

Style of Anne Vallayer-Coster (1744–1818)
Winter: Putti Around a Fire, in a Medallion (overdoor)
Oil on canvas, 39⅜ x 67⅜ in. (100 x 171.1 cm.)
French, about 1780
The Metropolitan Museum of Art
Gift of J. Pierpont Morgan, 1906
07.225.462

Elisabeth Vigée-Lebrun (1755–1842)
Madame Grand
Oil on canvas, oval, 36¼ × 28½ in. (92 × 72.4 cm.)
French, 1783
The Metropolitan Museum of Art
Bequest of Edward S. Harkness, 1940
50.135.2

Sir Joshua Reynolds (1723–1792)
Mrs. Baldwin
Oil on canvas, 36⅛ × 29⅛ in. (91.8 × 74 cm.)
English, about 1786
The Metropolitan Museum of Art
Gift of William T. Blodgett and his sister Eleanor Blodgett in memory of their father, William T. Blodgett, one of the founders of the Museum, 1906
06.1241

George Romney (1734–1802)
Mrs. Bryan Cooke
Oil on canvas, 50 × 39½ in. (127 × 100.3 cm.)
English, about 1787
The Metropolitan Museum of Art
Fletcher Fund, 1945
45.59.4

Elisabeth Vigée-Lebrun (1755–1842)
Queen Marie Antoinette
Oil on canvas, 106¾ × 76¾ in. (271 × 195 cm.)
French, 1788
Lent by the Musée National du Château de Versailles
SL 81.82.1

Madame Vigée-Lebrun painted various portraits of Marie Antoinette between 1779 and 1789. In her memoirs, first published in 1835, the painter described the queen as

> ...tall and admirably built, being somewhat stout, but not excessively so. Her arms were superb, her hands small and perfectly formed and her feet charming. She had the best walk of any woman in France, carrying her head erect with a dignity that stamped her queen in the midst of her whole court.... Her eyes were not large; in color they were almost blue and they were at the same time merry and kind. Her nose was slender and pretty, and her mouth not too large, though her lips were rather thick. But the most remarkable thing about her face was the splendor of her complexion. I never have seen one so brilliant, and brilliant is the word, for her skin was so transparent that it bore no umber in the painting. Neither could I render the real effect of it as I wished.

George Romney (1734–1802)
Elizabeth, Countess of Derby
Oil on canvas, 50 × 40 in. (127 × 101.6 cm.)
English, about 1790
The Metropolitan Museum of Art
The Jules Bache Collection, 1949
49.7.57

George Romney (1734–1802)
Mrs. George Horsley
Oil on canvas, 30 × 24⅞ in. (76.2 × 63.2 cm.)
English, about 1793
The Metropolitan Museum of Art
Bequest of Jacob Ruppert, 1939
39.65.1

Sir Henry Raeburn (1756–1823)
Edward Satchwell Fraser
Oil on canvas, 29½ × 24½ in. (74.9 × 62.2 cm.)
English, about 1798
The Metropolitan Museum of Art
Robert Lehman Collection
1975.1.234

SCULPTURE

Jean-Baptiste Pigalle (1714–1785)
Bust of Madame de Pompadour
Marble, H. 30 in. (76.2 cm.)
French, 1748–51
The Metropolitan Museum of Art
The Jules S. Bache Collection, 1949
49.7.70

Pair of Dolphins
Carved and gilded lindenwood, H. 47 in.
 (119.4 cm.)
French or Italian, about 1750
The Metropolitan Museum of Art
Gift of J. Pierpont Morgan, 1906
07.225.67ab

Jean-Baptiste Lemoyne (1704–1778)
Bust of Félicité-Sophie de Lannion,
 Duchesse de la Rochefoucauld
Marble, H. 28¾ in. (72.9 cm.)
French, 1774
The Metropolitan Museum of Art
Rogers Fund, 1934
34.91

Jean-Antoine Houdon (1741–1828)
Bust of Louise Brongniart
Marble, H. 20 in. (50.8 cm.)
French, 1779
The Metropolitan Museum of Art
Bequest of Benjamin Altman, 1913
14.40.670

Jean-Antoine Houdon (1741–1828)
Bust of Anne Audéoud
Plaster model, H. 19½ in. (49.5 cm.)
French, ca. 1779–80
The Metropolitan Museum of Art
Bequest of Bertha H. Buswell, 1941
42.23.2

Louis-Jacques Pilon (b. 1741)
Bust of George Washington
Marble
French, 1781
The Metropolitan Museum of Art
Bequest of Helen Hay Whitney, 1944
45.128.2

Jean-Antoine Houdon (1741–1828)
Bust of the Artist's Daughter, Sabine
French, 1788
The Metropolitan Museum of Art
Bequest of Mary Stillman Harkness, 1950
50.145.66

Atelier of Jean-Antoine Houdon
 (1741–1828)
Bust of Jean-Jacques Rousseau
Plaster painted to imitate terracotta, H.
 26½ in. (67.3 cm.)
French, late 18th century
The Metropolitan Museum of Art
Gift of J. Pierpont Morgan, 1908
08.89.2

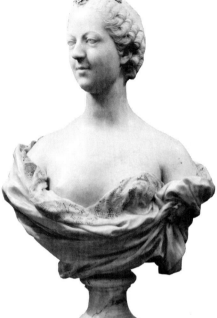

Atelier of Jean-Antoine Houdon
 (1741–1828)
Bust of Voltaire
Plaster painted to imitate terracotta, H.
 26½ in. (67.3 cm.)
French, late 18th century
The Metropolitan Museum of Art
Gift of J. Pierpont Morgan, 1908
08.89.1

Claude Michel, called Clodion
 (1738–1814)
Girl with Doves
Terracotta, H. 19½ in. (49.5 cm.)
French, late 18th century
The Metropolitan Museum of Art
The Jules S. Bache Collection, 1949
49.7.64

The Dead Bird
Marble, L. 9 in. (22.9 cm.)
Attributed to Joseph-Charles Marin
 (1759–1834)
French, late 18th century
The Metropolitan Museum of Art
The Jules S. Bache Collection, 1949
49.7.69

Venus Instructing Cupid
Marble, H. 17¾ in. (45.1 cm.)
In the manner of Etienne-Maurice Falconet
 (1716–1791)
French, late 18th century
The Metropolitan Museum of Art
Bequest of Benjamin Altman, 1913
14.40.671

DECORATIVE ARTS

Tapestries

The Audience of the Prince
From designs by G. L. Vernansal
 (1645–1729) and Jean Belin de
 Fonteney (1654–1715)
Tapestry (wool), 103 × 190 in.
 (261.6 × 482.6 cm.)
French (Beauvais), about 1700–32
The Metropolitan Museum of Art
Gift of Mrs. J. Insley Blair, 1948
48.71

François Boucher (1703–1770)
La Collation
Tapestry (wool and silk), 120 × 101 in.
 (304.8 × 236.5 cm.)
French (Beauvais), about 1762
The Metropolitan Museum of Art
Gift of Anne Payne Robertson, 1964
64.145.3

Porcelains

Covered Vase
Meissen
Hard-paste porcelain
German, about 1730
The Metropolitan Museum of Art
Bequest of Alfred Duane Pell, 1924
38.166.1ab

Pair of Powder-Blue Baluster-Shaped
 Vases
Hard-paste porcelain (Chinese, Ch'ien
 Lung period, 1736–95) mounted in
 French gilt bronze
French, about 1750
The Metropolitan Museum of Art
Gift of Mr. and Mrs. Charles Wrightsman,
 1977
1977.102.1,2

Pair of Ruffed Bustards
By J. J. Kandler
Meissen
Hard-paste porcelain
German, about 1752
The Metropolitan Museum of Art
Gift of Mrs. Jean Mauzé, 1959
59.176.1,2

Navette
Gold with pierced and engraved decoration
 with translucent *bleu-de-roi* enamel,
 D. 1, L. 5⅛, W. 1½ in.
 (2.5 × 13 × 3.8 cm.)
By Mathieu Coiny
French, about 1764
The Metropolitan Museum of Art
Bequest of Catherine D. Wentworth, 1948
48.187.483

Case for Sealing Wax (étui)
Four tones of gold in urn design, L. 4⅝ in.
 (11.7 cm.)
French, ca. 1764–65
The Metropolitan Museum of Art
Bequest of Catherine D. Wentworth, 1948
48.187.492ab

Birdcage
Mahogany, wire, and sheet metal in an
 octagon of ogee arches; pierced dome
 top with foliate finial, H. 30 in. (76.2
 cm.)
English, about 1765
Lent by the Cooper-Hewitt Museum, New
 York
SL 81.113.6

Box (bonbonnière)
Colored enamel on copper in the shape of a
 nesting hen and chicks, Diam. 3¼ in.
 (8.3 cm.)
South Staffordshire
English, about 1765
The Metropolitan Museum of Art
Gift of Irwin Untermyer, 1964
64.101.815

Snuffbox
Carved seventy-five-carat sapphire
 surrounded by rose-colored diamonds
 set in a gold box with pink enamel, L.
 2½ in. (6.3 cm.)
French, about 1765
Lent by Dona and Bernard C. Solomon
SL 81.87.6

Needlecase (étui)
Moss agate mounted with gold borders of
 scrolls and floral swags; band of white
 enamel at rim, L. 4⅝ in. (11.7 cm.)
English, ca. 1765–75
The Metropolitan Museum of Art
Bequest of Kate Read Blacque in memory
 of her husband, Valentine Alexander
 Blacque, 1937
38.50.49ab

Jean-Baptiste Nini (1717–1786)
Five Portrait Medallions:
 Albertine de Nivenheim
 Susanne Jarente de la Reynière
 An Unknown Lady
 Maria Teresa, Empress of Austria
 Catherine II, Empress of Russia
French, dated between 1768 and 1771
The Metropolitan Museum of Art
Gift of James Hazen Hyde, 1949 and 1952
49.20.10, 52.133.2, 52.189.4, 9, 11

Snuffbox
Gold and enamel, L. 3 5/16 in. (8.4 cm.)
Maker: Jean Joseph Barrière
French, Paris, 1769/70
The Metropolitan Museum of Art
Gift of J. Pierpont Morgan, 1917
17.190.1211

Nécéssaire
Gold frame of repoussé scrolls with panels
 of moss agate trimmed with emeralds,
 rubies, and diamonds, L. 3¼, W.
 3 9/16, D. 2½ in. (8.3 × 9 × 6.3 cm.)
By James Cox
English, about 1770
The Metropolitan Museum of Art
Gift of Mrs. Florence Harris Schlubach,
 1957
57.128a–o

Box
Mottled pink and white enamel on copper
 with a spotted black spaniel dog on top,
 D. 1⅞, L. 1 9/16, W. 1¼ in.
 (4.8 × 4 × 2.8 cm.)
South Staffordshire
English, about 1770
The Metropolitan Museum of Art
Gift of Louise Knobloch, 1966
66.43.1ab

Nécéssaire
Green ceramic ground with two colored
 landscapes; gilt figural mounts,
 4½ × 1¾ in. (11.5 × 4.5 cm.)
Battersea
English, about 1770
The Metropolitan Museum of Art
Gift of J. Pierpont Morgan, 1917
17.190.1094

Door Lock and Key
Gilt bronze and steel, made for the Palais
 Paar, Vienna
French, about 1770
The Metropolitan Museum of Art
Gift of Mr. and Mrs. Charles Wrightsman,
 1971
1971.206.33ab

Box in the Shape of a Blackamoor's Head
Carved amethyst quartz set with rubies,
 turquoise, diamonds, emeralds, and
 moonstone in gold and silver mounts, H.
 2½ in. (6.3 cm.)
French, 3rd quarter of 18th century
Lent by the Cooper-Hewitt Museum, New
 York
SL 81.113.2

Bilboquet
Carved ivory engraved with sportive
 amorini playing with *bilboquets* in a
 meadow, inscribed *MENUS PLAISIRS
 DU ROY, VERSAILLES*, L. 8 in. (20.3
 cm.)
French, about 1775
Lent by the Cooper-Hewitt Museum, New
 York
SL 81.113.3

Scent Bottle
Crystal with engraved gold top with
 monogram *L*, H. 2 in. (5 cm.)
French, about 1775
Lent by Dona and Bernard C. Solomon
SL 81.87.5ab

Clock
Mat and burnished gilt-bronze framework
 enclosing white enameled metal dial and
 Sèvres porcelain plaques
French, about 1775
The Metropolitan Museum of Art
Gift of Samuel H. Kress Foundation, 1958
58.75.62

Dancers (eight from a set of twelve)
Gilt-bronze figures in relief, after the
 Roman mural paintings from the Villa of
 Cicero at Pompeii, discovered between
 1749 and 1763–64
French, last quarter of 18th century
The Metropolitan Museum of Art
Rogers Fund, 1926
26.240.1–12

Furniture Mount
Gilt-bronze, from the corner of a piece of
 furniture
French, last quarter of 18th century
The Metropolitan Museum of Art
Gift of J. Pierpont Morgan, 1906
07.225.510.312b

Needlecase (étui)
Carved ivory in the form of enchained
 hearts with an *amor* garlanding their
 frames
French, about 1780
Lent by the Cooper-Hewitt Museum, New
 York
SL 81.113.5

Mantel Clock
Marble case with gilt-bronze elements
Attributed to Pierre-Philippe Thomire
 (1751–1843) from models supplied by
 the sculptor Louis-Simon Boizet
 (1743–1809) after designs by the
 architect François-Joseph Belanger
 (1744–1818); the movement by Jean-
 Baptiste Lepaute le jeune (1727–1802)
French, about 1782
The Metropolitan Museum of Art
Gift of Mr. and Mrs. Charles Wrightsman,
 1972
1972.284.16

Case for Sealing Wax (étui)
Blue enamel on gold in star design; borders
 of white enamel pearls, L. 4⅝ in. (11.7
 cm.)
French, ca. 1784–85
The Metropolitan Museum of Art
Bequest of Kate Read Blacque in memory
 of her husband, Valentine Alexander
 Blacque, 1937
38.50.45ab

Relief Ornament with Portraits of Louis XVI and Marie Antoinette
Gilt bronze
French, about 1785
The Metropolitan Museum of Art
Gift of J. Pierpont Morgan, 1906
07.225.510.326

Fashion Doll (piavola di Franza)
Painted porcelain doll dressed in a *grand
 panier robe à l'anglaise* of a cream-
 colored ground brocaded in gold
 metallic thread and green and rose-
 colored silks in a floral and foliate
 pattern, trimmed with gold metallic
 braid, sable (?), lace, gauze, silver
 sequins, and paste; petticoat of gold silk
 covered with gauze appliquéd in a
 polychrome silk floral design with silver
 sequins and gold braid bowknots edged
 in lace; headdress of pink velvet
 trimmed with sable (?), gauze, paste,
 and ostrich plumes, H. 16 in. (40.6 cm.)
French (?), about 1788
Lent by a private collection, New York
SL 81.73

Parisian dressmakers sent fashion dolls to
the provinces and to other countries to
acquaint ladies with the latest styles. A
fashion doll was sent to the English court
as early as 1391 to show what the queen of
France was wearing. In the eighteenth
century there was a great demand for the
poupée de la mode, as it allowed ladies to
gauge the effect of a costume from all sides
and permitted dressmakers to study the
detailed construction of dresses, albeit in
miniature. In 1748 Lady Anson wrote from
London that a doll dressed exactly like
Madame de Pompadour had arrived:

> She has three compleat Dresses, one the
> *habit de Sage-Femme*, which is *de
> Grand Ceremonie*, a *Robe pour les
> Spectacles, Les Promenades*, etc.,
> etc., and one *Robe de negligé* for her
> morning wear; with all sorts of
> *Coiffures, Agréments* suited to them
> all, and written explanations and
> directions to every part of her attire.

The Bayerisches National Museum,
Munich, has a similar doll with a large

wardrobe, complete with a printed cotton *robe à la française* with a tiny pair of *engageantes* (lace sleeve ruffles). The French fashion doll exhibited here was sent from the rue Saint-Honoré in Paris to a noble Venetian family. The Venetians irreverently referred to these dolls as *piavoli di Franza*, or "she-devils of France." The style of the plumed *pouf* and the trimmings on the dress are not unlike those worn by Marie Antoinette in Elisabeth Vigée-Lebrun's 1788 portrait. It is tempting to attribute this doll to Rose Bertin, but it could just as easily have been made by competitors, like Madame Lompey or Madame Angier.

Spectacles and Case
Silver-framed glass; case of shagreen on a
 wooden core, L. 5 in. (12.8 cm.)
French, about 1795 (?)
Lent by the Cooper-Hewitt Museum, New
 York
SL 81.113.4ab

Samuel Percy
**Count Joseph Borowleski, the Polish
 Dwarf**
Wax miniature
Irish, 1798
The Metropolitan Museum of Art
Glenn Tilley Morse Collection, Bequest of
 Glenn Tilley Morse, 1950
50.187.30

Bather
Gilt-bronze furniture mount
French, late 18th century
The Metropolitan Museum of Art
Gift of J. Pierpont Morgan, 1906
07.225.510.205

"Trophée Champêtre"
Gilt-bronze furniture mount
French, late 18th century
The Metropolitan Museum of Art
Gift of J. Pierpont Morgan, 1906
07.225.510.488

Two Sections of a Frieze
Gilt-bronze furniture mounts
French, late 18th century
The Metropolitan Museum of Art
Gift of J. Pierpont Morgan, 1906
07.225.510.586ab

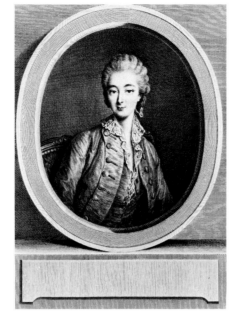

Miniature Paintings

Thomas Forster (active 1690–1713)
Portrait of a Nobleman
Plumbago on vellum, 4⅜ x 3⅝ in. (11.1 x
 9.2 cm.), signed and dated *T Forster /
 Delin / 1700*
The Metropolitan Museum of Art
Rogers Fund, 1944
44.36.2

Thomas Forster (active 1690–1713)
Portrait of a Lady
Plumbago on vellum, 4⅜ x 3¼ in. (11.1 x
 8.3 cm.), signed and dated *T Forster /
 delin / 1700*
The Metropolitan Museum of Art
Rogers Fund, 1944
44.36.5

Thomas Forster (active 1690–1713)
Portrait of a Nobleman
Plumbago on vellum, 4⅜ x 3⅝ in. (11.1 x
 9.2 cm.), signed and dated *Fo / 1705*
The Metropolitan Museum of Art
Rogers Fund, 1944
44.36.4

Christian Friedrich Zincke
(1683/84–1767)
**Portrait of a Lady, Called
 Mrs. Vanderbank**
Enamel on copper framed with brilliants,
 1⅜ x 1½ in. (3.5 x 3.8 cm.), ca. 1720
The Metropolitan Museum of Art
Gift of the Misses Sarah and Josephine
 Lazarus, 1888–95. The Moses Lazarus
 Collection
95.14.99

Christian Friedrich Zincke
(1683/84–1767)
Richard Abell
Enamel on copper framed with brilliants,
 1¾ x 1⅜ in. (4.4 x 3.5 cm.), signed on
 the reverse and dated 1724
The Metropolitan Museum of Art
Gift of the Misses Sarah and Josephine
 Lazarus, 1888–95. The Moses Lazarus
 Collection
95.14.61

William Prewett (active 1733–40)
Portrait of a Young Man
Enamel on copper in gilt mount, 1⅞ x 1½
 in. (4.8 x 3.8 cm.), ca. 1736
The Metropolitan Museum of Art
Bequest of Millie Bruhl Fredrick, 1962
62.122.113

Christian Friedrich Zincke
(1683/84–1767)
Portrait of a Young Man
Enamel on copper in contemporary mount,
 1¾ x 1½ in. (4.4 x 3.8 cm.), ca. 1750
The Metropolitan Museum of Art
Bequest of Catherine D. Wentworth, 1948
48.187.495

Portrait of a Mother and Child
Watercolor on ivory in gilt mount, diam.
 2⅜ in. (6 cm.), signed *RC*
French, ca. 1770
The mother wears a miniature.
The Metropolitan Museum of Art
Bequest of Millie Bruhl Fredrick, 1962
62.122.81

Louis XV
Watercolor on vellum, mounted in a frame
 set with rose-colored diamonds and
 surmounted by double Ls and a crown,
 2⅛ x 2¹³⁄₁₆ in. (5.4 x 7.1 cm.)
French, ca. 1770
The Royal arms are engraved on the back
 cover.
The Metropolitan Museum of Art
Bequest of Millie Bruhl Fredrick, 1962
62.122.84

Peter Adolf Hall (1739–1793)
**The Portrait Painter Louis Maurice
Joseph**
Watercolor on ivory in gilt mount, 2⁵/₁₆
x 2⅝ in. (5.9 x 6.7 cm.), signed *hall* and
datable 1772
The Metropolitan Museum of Art
Gift of the Misses Sarah and Josephine
Lazarus, 1888–95. The Moses Lazarus
Collection
95.14.53

**Attributed to Archibald Robertson
(1765–1835)**
Sir Joshua Reynolds
Watercolor on ivory in gilt mount, 3 x 2½
in. (7.6 x 6.4 cm.). After a self-portrait
of 1773.
The Metropolitan Museum of Art
Bequest of Geraldine Winslow Goddard,
1924
24.21

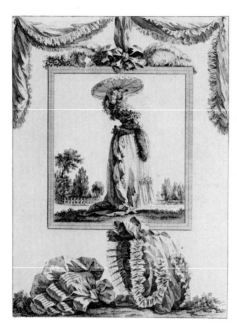

Portrait of a Lady
Watercolor on ivory in gold mount, 2⅛ x
1¾ in. (5.4 x 4.4 cm.), ca. 1778
The Metropolitan Museum of Art
Bequest of Millie Bruhl Fredrick, 1962
62.122.138

George Engleheart (1750/53–1824)
Mrs. Peter De Lancy
Watercolor on ivory in gilt mount attached
to a bracelet of woven hair, 1⁵/₁₆ x
1⅛ in. (3.3 x 2.8 cm.), ca. 1780
The Metropolitan Museum of Art
Fletcher Fund, 1938
38.146.16

Peter Adolf Hall (1739–1793)
Portrait of a Lady
Watercolor on ivory in an enameled frame
set with brilliants, diam. 2⅜ in. (6.2
cm.), signed *hall*, ca. 1780
The Metropolitan Museum of Art
Bequest of Isaac D. Fletcher, 1917. Mr.
and Mrs. Isaac D. Fletcher Collection
17.120.119

**Portraits of a Lady, a Gentleman, and
Two Children**
Watercolor on ivory mounted in a gold
bracelet, each 1⁵/₁₆ x ¹³/₁₆ in. (3 x
2.1 cm.)
French, ca. 1785
The Metropolitan Museum of Art
Bequest of Collis P. Huntington, 1900
26.168.67–70

**Portraits of a Lady, a Gentleman, and
Two Children**
Watercolor on ivory mounted in a gold
bracelet, each 1⅛ x ¹³/₁₆ in. (2.8 x
2.1 cm.)
French, ca. 1785
The Metropolitan Museum of Art
Bequest of Collis P. Huntington, 1900
26.168.63–66

Heinrich Friedrich Füger (1751–1818)
Portrait of a Swedish (?) Lady
Watercolor on ivory in gilt mount, 1¼ x ⅞
in. (3.2 x 2.3 cm.), ca. 1785
The Metropolitan Museum of Art
Fletcher Fund, 1941
41.68

Jean Laurent Mosnier, 1743/44–1808
Louis XVI
Watercolor on ivory in gilt mount, diam.
2⁹/₁₆ in. (6.5 cm.), signed and dated
J. L. Mosnier, 1790
The Metropolitan Museum of Art
Bequest of Millie Bruhl Fredrick, 1962
62.122.69

Style of Peter Adolf Hall (1739–1793)
Portrait of a Lady
Watercolor on ivory, diam. 2⁷/₁₆ in. (6.2
cm.), ca. 1790
The Metropolitan Museum of Art
Bequest of Millie Bruhl Fredrick, 1962
62.122.137

Portrait of a Lady
Watercolor on ivory in gilt mount set
against a background of braided hair,
1⅛ x ¾ in. (2.8 x 1.9 cm.)
French, ca. 1790
The Metropolitan Museum of Art
Bequest of Mary Clark Thompson, 1924
24.80.514

Portrait of a Huntsman with His Dog
Watercolor on ivory in gilt mount, 2¾ x
3⁵/₁₆ in. (7 x 8.3 cm.), signed and
dated *Mortier / an 3me* [1795]
The Metropolitan Museum of Art
Gift of Mrs. Louis V. Bell, in memory of
her husband, 1925
25.106.15

**Pierre Marie Gault de St. Germain
(1754–1842)**
**Marie Thérèse Charlotte, Daughter of
Louis XVI**
Watercolor on ivory in gilt mount, diam.
2⅜ in. (6 cm.), signed and dated *JJ
Degault 1795* and inscribed with the
sitter's name and date of birth
The Metropolitan Museum of Art
Bequest of Millie Bruhl Fredrick, 1962
62.122.67

Frederick the Great
Enamel on copper, 2¾ x 3⁷/₁₆ in. (7 x
8.9 cm.)
German, late 18th century
Interior of the lid of a box.
The Metropolitan Museum of Art
Gift of Eduard and Helen Naumann, 1963
63.77

Miniatures of Eyes
Watercolor on ivory mounted as four
brooches, a stick pin, and a ring,
British, late 18th or early 19th century
The Metropolitan Museum of Art
Gift of Mr. and Mrs. John W. Starr, 1954
54.128.1–3, 4, 6, 7

Jacques Charlier (b. ca. 1720; d. 1790)
Leda and the Swan
Watercolor on ivory in gold mount, 2 x 2⁷/₈
in. (5.1 x 7.3 cm.)
After a painting by Boucher
The Metropolitan Museum of Art
Bequest of Millie Bruhl Fredrick, 1962
62.122.63

Portrait of an Officer
Style of Jean André Rouquet
Enamel on copper in mount set with
brilliants, 1¼ x 1¹/₁₆ in. (3.2 x 2.7
cm.)
The Metropolitan Museum of Art
Gift of the Misses Sarah and Josephine
Lazarus 1888–95. The Moses Lazarus
Collection
95.14.68

Rosalba Carriera (1675–1757)
Portrait of a Gentleman in Armor
Gouache on ivory in gilt mount, 3¹/₁₆ x
2¼ in. (7.8 x 5.7 cm.)
The Metropolitan Museum of Art
Rogers Fund, 1949
49.122.2

LES HAZARDS HEUREUX DE L'ESCARPOLETTE

Dédiés à Monsieur Honoré Fragonard
Peintre du Roi

Lenders to the Exhibition

The mannequins were developed by the Kyoto Costume Institute in conjunction with The Metropolitan Museum of Art.

A la Vieille Russie, New York
Art Institute of Chicago
Mr. and Mrs. Robert R. Atterbury, Jr., Ridgewood, New Jersey
The Brooklyn Museum
Iris Brown
Chicago Historical Society
Mr. and Mrs. F. Norman Christopher, New Canaan, Connecticut
Cooper-Hewitt Museum, New York
Fairfield Historical Society, Fairfield, Connecticut
Cora Ginsburg, Tarrytown, New York
Timothy John, New York
Martin Kamer, Switzerland
Musée Carnavalet, Paris
Musée de la Mode et du Costume, Paris
Musée des Arts Décoratifs, Paris
Musée National du Château de Versailles
Museum of the City of New York
National Museum of American History, Smithsonian Institution,
 Washington, D.C.
Nordiska Museum, Stockholm
Philadelphia Museum
Rijksmuseum, Amsterdam
Shannon Rodgers, New York
Rosenborg Palace, Copenhagen
Count Maurizio Antonio Sammartini, Venice
Dona and Bernard C. Solomon
Tirelli Collection, Rome
Union Française des Arts du Costume, Paris
Van Cleef and Arpels, Paris

A number of private collectors in New York and Paris lent anonymously.

Staff of Costume Institute

Stella Blum, *Curator*
Diana Vreeland, *Special Consultant*
K. Gordon Stone, *Associate Museum Librarian*
Paul M. Ettesvold, *Assistant Curator*
Jean R. Druesedow, *Assistant Curator*
Elizabeth N. Lawrence, *Master Restorer*
Lillian A. Dickler, *Senior Administrative Assistant*
Elaine F. Shaub, *Assistant to Consultant*
Irja Zimbardo, *Senior Housekeeper*
Dominick Tallarico, *Principal Departmental Technician*
Mavis Dalton, *Associate Curator, part-time*
Kiki Smith, *Curatorial Assistant*

Exhibition Staff

Exhibition conceived and organized by Diana Vreeland
Assistant to Mrs. Vreeland: Stephen Jamail
Exhibition Design: Jeffrey Daly and Maureen Healy
Lighting: William L. Riegel
Exhibition Assistants: June Bové, Richard DeGussi-Bogutski,
 Sarah Richardson, and Lindsay Soutter

Many thanks to the staff members of the following departments
for their advice and assistance in the mounting of this exhibition:

European Paintings
European Sculpture and Decorative Arts
Prints and Photographs
Arms and Armor
Textile Conservation
Objects Conservation
Office of the Vice President for Operations
Design
Buildings
Security
Office Service
Photograph Studio
Telephone Switchboard
Public Information

Music compiled by Stephen Paley and Laura Harth, with special
thanks to William S. Paley and Walter Yetnekoff for the use of
CBS Records studios.
Scent: "Nahema" by Guerlain
Jewelry by Kenneth Jay Lane
Orders and decorations arranged by Kirk Allan Adair
Two bouffant coiffures by Harold Koda
Painted heads by Linda Velez
Boots adapted by Judy Brindesi
Flowers donated by Corham Artificial Flowers and by Anita
 Flower and Novelty Company
Stockings provided by Capezio Ballet Makers
Lace donated by Weiner Laces, Inc.
Ribbon donated by C. M. Offray and Son, Inc.
Many thanks to Oomphies, Inc.
Special thanks to Bill Cunningham and Angela Forenza
With deepest appreciation to Umberto Tirelli, Piero Tosi, and
 Vera Marzot for their great assistance.

Volunteers
for the Installation

Volunteers
for Restoration

A special note of thanks to the many volunteers who worked with great devotion and effort on this exhibition:

Kirk Allan Adair
Akira
Margaret Avery
Francesca Bianco
Ellen Burnie
Lucinda Childs
Donna Corvi
Patricia Cresswell
Alan Faucher
William Gibson
Elizabeth Houghton
Flora Husband
Josita Károlyi
Joel Kaye
Alida Kilburn
Lisa Kung
Susan Lamb
Katel le Bourhis
Anne Miller
Madge Miller
Jasmin Paganelli
Nancy Präger-Benett
Lucy Richards
Barbara Rosen
Simone Scheer
Jocelyn Schwartzman
C. J. Scott
Joe Simon
Cynthia Sirko
Robert Vitale
Terry Wendell
Nina Wood
Marielle Worth

Ethel Altschul
Polly Anderson
Ilse Babes
Mary S. Barker
Holly Bisset
Caroline Blish
Rose Marie Breguet
Jean Brodsky
Marion Budsanosky
Russell Bush
Virginia Caldwell
Josephine Cardello
Judith Carmany
Barbara Chafkin
Mimi Chan
Anita Child
Lucinda Childs
Helen Clark
Antoinette Cusumano
Clothilde Daniel
Elizabeth Daubeny
Emily Derenberg
Helen DiBlasio
Ellen Ann Dobrivir
Millicent Dworkin
Ruth Ehrlich
Virginia Ferguson
Posy Feuer
Barbara H. Finch
Jane Fiore
Anne Fischer
Judith Flaxman
Marily Francis
Leslie Glass
Ellen Granick
Marie Hagen
Madelyn Harris
Margot Hartmann
Norma Hensler
Eleanor Holborow
Lisa Jacobs
Judith Johnston
Susan Johnston
Joanne Josephy
Lila Kalison
Lizzi Katz
Ellen Kenny
Giza Kent
Ilse Kessler
Laura Kopetka
Shula Koton

Lisa Kung
Ann Langford-Hamber
Georgia Langhorne
Kelle Lebwith
Georgette Levy
Charlotte Liebov
Carla Ann Litwak
Edna Lonstein
Virginia Mayor
Leonore Messmore
Jane Miller
Winifred Minott
Helen Olsen
Vicky Olsen
Jasmin Paganelli
Ellen Paganussi
Nathalie Pion
Eleanor Powell
Dolores Randall
Rosalind Rappaport
Laura Reiburn
Helene Rittenberg
Anne Robbins
Lillian Rouse
Sarah Rowe
Mary Russioniello
Belle Sabin
Judith Sommer
Fran Spar
Susan Spar
Sylvia Spitzer
Kuniko Steel
Yean Sun
Yoko Takahashi
Andrea Tholl
Freya Van Saun
Evelyn Voice
Lily Vulliemoz-Tobler
Jill H. Weitzman
Joan Whelan
Phyllis Wickham
Joan Wing
Ann Wiss
Esther Zisser